Dan Fern

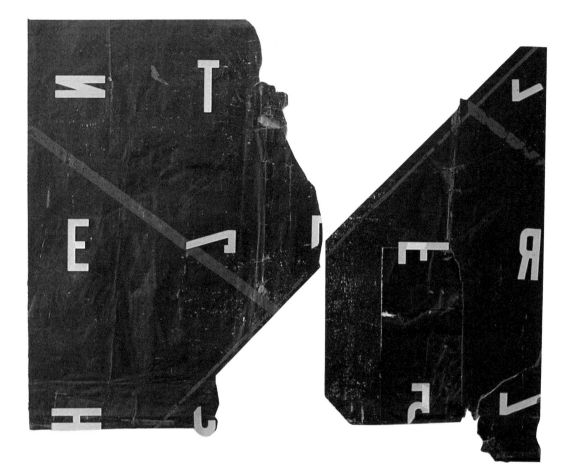

An ADT DESIGNFILE
Architecture Design and Technology Press
128 Long Acre
London
WC2E 9AN

ADT Press is an imprint of Longman
Group UK Limited

First published 1990

© Dan Fern 1990
Introduction text © Rick Poynor 1990

British Library Cataloguing in
Publication Data
A CIP catalogue record for this book is
available from the British Library

ISBN 1 85454 149 8

Printed in Hong Kong

Dan Fern

Works with Paper

Edited by Rick Poynor
Architecture Design and Technology Press, London

Works with Paper

Introduction by Rick Poynor

For better or worse, the split between typography and image-making is one of the most striking characteristics of British graphic design. The orderly separation of elements apparent in so many designs is a reflection of the way that the disciplines themselves are taught. Designers and illustrators might be compelled to collaborate by their shared commitment to the medium of print, but their art school training does little to foster mutual sympathy or understanding. It contrives, if anything, to keep them apart. Designers learn to solve problems, to be rational and logical, to subordinate self-expression to the demands of the brief. Illustrators, on the other hand, are encouraged to look inside themselves for the answers, to develop a highly personal style, to become artists.

Neither can exist without the other, but the illustrator suffers the greater loss. Without a grounding in typography, or a proper understanding of the design process, the illustrator will always play second fiddle to the art director. The average art director, meanwhile, knows very little of art. So long as the illustration fills the prescribed space on the page to decorative effect the job has been done.

What sets Dan Fern apart from most other British illustrators and gives his work its particular interest is that he has been through a training that encompasses both disciplines. Fern studied graphic design before moving on to study illustration. 'My aim since then has been to try to find a fusion of typography and graphics with image-

making, which would not only be satisfying to my individual needs as an artist, but which would enable me to work across a wide spectrum of commercial outlets,' he has said. To a considerable extent he has succeeded. Fern is Professor of Illustration at the Royal College of Art; he works as a commercial illustrator, creating posters, stamps, magazine covers, record sleeves, corporate identities and packaging, as well as teaching the subject; he produces personal, non-commissioned pieces for exhibition; yet his illustration reveals a tutored grasp of design principles and issues. If Fern has a recurring subject as an artist it is the language of graphics itself. Printed letterforms, numbers, symbols, diagrams and grids are the raw material of his collages, and collage, his preferred medium, allows him to combine papers of different weights, colours, textures, age and provenance in endless permutations. At the end of the 1980s, a vogue for collage swept through British graphic design, much of it poorly considered, but Fern's work remained distinctive for the purity, simplicity and discipline of its graphic forms. The process of picture-making, for Fern, is a process of elimination rather than accretion, a stripping away of superfluous material until only the essential remains. Although figurative elements are sometimes imposed on him by clients, they are a distraction from the formal issues he prefers to explore. Fern's personal pieces are noticeably more sensual and abstract, allowing the structural tensions within the images, the sense of order, dis-

'Philmar' transfer book
(Collection Dan Fern)

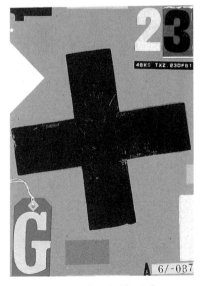

Dan Fern: *G2*, print/sketch for
Wiggins Teape mural (1982)

Turkish tin toy
(Collection Dan Fern)

ruption, resolution and harmony, to be perceived more clearly.

In childhood, Fern believes, lies the source of adult originality. In his own case there is a remarkable continuity between boyhood interests and his later art. Fern is a tireless collector of the tin toys and colouring books he loved as a child. He enjoyed making model aeroplanes and remembers admiring the graphics of a Messerschmidt 109; echoes of the plane's markings and camouflage survive in Fern's graphic collisions of number and shape. The pages of a stamp album he laid out as a seven-year-old show the same concern for meticulous arrangement now seen in his collages. Fern was fascinated by the regularity of the album's grid and the combination of imagery,

type and numbers on the stamps themselves. Today the plan chests of his North London studio overflow with stamps from Turkey, Afghanistan and India, as well as more complex examples of postal history from around the world: envelopes covered by franking marks, stamps and seals to form accidental designs of great subtlety; ancient letters written in flowing scripts on paper as brittle as dried-out leaves, or etched by corrosive inks into a fragile tracery of apertures. The habits of the stamp collector live on in the Chinese notebooks lined for calligraphy practice in which Fern mounts examples of the printed ephemera that fascinate him – tickets, matchbox graphics and luggage labels. Other drawers in his studio contain wood type, prize tickets from 19th-century

7

agricultural shows, children's alphabet books, letters from a Czechoslovakian stationer (a form of primitive Letraset), 'Kan-U-Go' game cards, 'Econasign' stencils, post-war ration books, ink rubbings of Chinese tombstones, and fragments of Islamic papyrus. Fern is constantly adding to his collection, selecting each item with inordinate care, and he spends much time sifting meditatively through his plan chests, inspired as much by the grain and texture of the pieces in his hands as by their delicacy or beauty. Some of this material, particularly the letterforms, finds its way into his collages. Much of it exerts a subtler influence. Marks made on envelopes by official hands, edges eaten away by the passage of time, the criss-cross of handwriting glimpsed through paper, or the accidental overlap of two items in a pile, can suggest unfamiliar approaches to composition and colour. In much the same spirit, Fern leaves cardboard frames in the drawers where he keeps his work to isolate by chance details that might prove to be stronger than the whole.

From an early age Fern expected to go to art school. His father, a Labour councillor from a large mining family, made detailed drawings of buildings and landscapes using a mapping pen, and the family would spend evenings in the days before television making pictures at the table. As a teenager, living in Gainsborough, Lincolnshire during the late 1950s, Fern travelled to nearby churches, renovating tombstones and memorials, and he hand-lettered certificates for the local

Dan Fern: Collage
(1972–3)

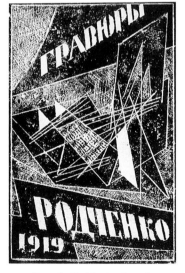

Alexander Rodchenko: Cover for
a portfolio of linocuts (1919)

music competition. After grammar school he went to Manchester College of Art in 1964 to take a diploma in graphic design. Fern studied typography and made posters using a combination of collage, printing and figurative drawing in a decorative, surrealistic style typical of the *Yellow Submarine* era. Increasingly, he was drawn to picture-making rather than to graphics. In his degree show in 1967, he showed two illustrated children's books and it was largely on the strength of these that he was given a place on the Royal College of Art postgraduate illustration course run by Brian Robb. The relationship Fern formed with another tutor, Quentin Blake, was to prove particularly significant. 'He'd just been brought in and right from the start I hit it off with him –

I'd simply never met anyone with his depth of knowledge about illustration, literature, theatre, art history and so on – and the way he talked about making pictures, criticized our work and later on ran the course was the way that I learned to do it.'

At the RCA, Fern continued to work on ideas for children's books; one he wrote and illustrated, titled *Wandering Albert Ross*, attracted the interest of a publisher, but Quentin Blake was unenthusiastic, and by the time of his degree show in 1970 Fern knew this was not the direction he wanted to take. The show, which also contained a number of posters, was well received. On the strength of it, Tommy Roberts, founder of Mr Freedom, the King's Road fashion shop, asked Fern to design a

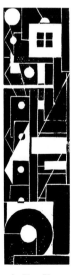

Jan van der Zee: Linocut from
The Next Call, No. 7 (1925)

Hendrik Werkman: Cover of
The Next Call, No. 9 (1926)

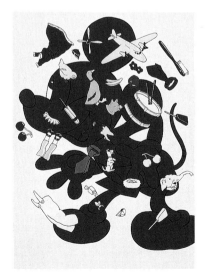

Dan Fern: T-shirt for Mr Freedom
(screenprint, 1969)

number of posters and he also received a poster commission from Shell. In 1970, Fern responded to the invitation of a designer friend, Keith McEwan, and moved with his wife, Kate, to Amsterdam, where he worked in a studio of expatriates. The next three years were a time to experiment and develop professional skills. Fern made an animated film, drew a strip cartoon for a bank and designed magazine advertisements, usually handling the type himself. The Dutch regarded the studio as a bunch of 'crazy, over-the-top, freaky Englishmen,' but gave them work anyway because their output was fresh and innovative. Fern, meanwhile, was discovering the pioneering designs of Piet Zwart, Hendrik Nicolaas Werkman and the De Stijl typographers, a purist aesthetic that would, in time, combine with his admiration for the Russian Constructivists to have a determining influence on his art. When he returned to London in 1973, Fern put together a portfolio of work that reflected his new preoccupations. Pentagram partner David Hillman, then art director of *Nova* magazine, gave him work, as did Clive Crook at *The Sunday Times Magazine*; three intensely worked and rather lush full-page illustrations for the magazine's cookery pages typify Fern's approach at this point. Elements of the image were drawn or air-brushed separately, then cut out and mounted in highly formalized, even symmetrical arrangements, sometimes combined with type.

In 1974, Quentin Blake asked Fern if he would like to share his teaching commitment at the RCA, which meant taking on a day a week for a term. Fern agreed and found himself cast in the role of tutor to an impressive line-up of final-term students: Sue Coe, Su Huntley, Paul Leith, Glynn Boyd Harte. The following year, Brian Robb invited Fern to return and he has remained with the department ever since, teaching for one day a week, then two, then three, and finally replacing Blake as full-time head of illustration in 1986. Fern's involvement in the department has proved to be of decisive importance to his own development as an artist. The art teacher's position is a particularly exposed one, requiring a high degree of self-awareness and self-criticism if he is to maintain credibility with the students. Showing personal work to the group forces the teacher to see its shortcomings through their eyes. To survive what could have been a destructive experience, Fern had to subject his art and ideas to the same process of continual review that he applied to the students. Fern does not regard himself as naturally articulate, but teaching has forced him to develop the language and confidence to account for and defend his own intuitions.

He quickly became his own harshest critic. The mid-1970s was a time of upheaval in the college's illustration department. A new wave of artists, inspired by an earlier generation of RCA illustrators (Stewart MacKinnon, Terry Dowling, Sue Coe) and the political radicalism and anger of Punk, was bringing fierce commitment, shocking subject matter and innovative techniques to the once sedate and bookish world of British illustra-

tion. For Fern, tutor of Robert Mason, Russell Mills, Ian Pollock and other spiky newcomers, this period provided a 'salutary experience'. Dissatisfied with much of his own output, and viewing himself as a late-starter and insufficiently purist to boot, Fern burned the earlier pieces he no longer liked. What he did admire was the 'thrown-together' look of Punk graphics and in the late 1970s, the bright, simple, silk-screen images composed of colouring book grids began to be replaced by more or less abstract pieces, full of bold shapes and torn edges, which anticipate the mature work of the 1980s.

It is virtually a truism to say that the most challenging illustration occurs where the artist has a reservoir of experience accumulated through personal work to draw on for commissions. The speed of commercial projects, the use of supplied subject matter, the physical nature of print, and the other inevitable constraints of the brief allow much less scope for experiment than work undertaken at a less forced pace in the artist's own time. Personal projects give the illustrator a chance to return obsessively to the same highly personal themes and motifs, to pursue an idea through a series of pictures with the freedom of the fine artist. Throughout the 1980s, Fern has combined commercial work for a broad range of clients with personal projects undertaken for their own sake and sometimes with a view to exhibition. The surprising thing, in some ways, is the closeness of the relationship between the two strands. Given

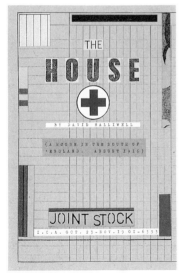

Dan Fern: 'The House', poster for
Joint Stock Theatre Group (collage, 1977)

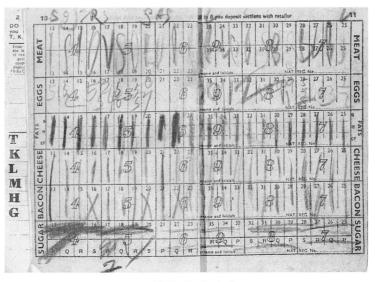

World War II ration book
(Collection Dan Fern)

the almost complete abstraction of his self-generated pieces, this is a measure of the formal originality and daring of Fern's work as an illustrator. Very few British illustrators, even now, have the experience or confidence to carry off a suite of images such as the one Fern produced for the Art Directors Club Nederland's *Annual of Dutch Advertising* in 1986. The collages draw on a handful of dislocated representational elements – a torn diagram of a saw, a line drawing of a cockerel, the corner of a Union Jack – but these are transformed by their abstract settings into visual ciphers stripped of anything other than a coded meaning. The precision of their placement in these deceptively random images forces the viewer to consider them as compositional units, no more

or less significant than this mauve rectangle or that strip of masking tape. A certificate Fern created for the BBC Design Awards in 1987 shows his method of typographic integration at its most articulate. The sacrosanct letters 'BBC' are irreverently sliced and truncated by diagonal slabs of torn and straight-edged paper, but they still emerge clearly from the testcard intricacy of the background, so carefully is the collage composed. Even the authenticating rubber stamps in the margins are treated as components of the image.

Similar compositional concerns were evident in the collages, prints and type constructions Fern showed in 1985 at London's Curwen Gallery. It is impossible to take in one of Fern's collages at a single glance and this is entirely deliberate. Fern

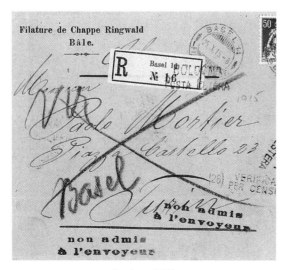

Envelope (1915)
(Collection Dan Fern)

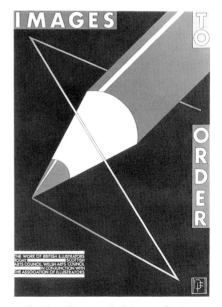

Dan Fern: 'Images to Order', poster for the
Association of Illustrators (airbrush, 1979)

has a fondness for pushing events out to the edges of his pictures, drawing the eye on a journey across the image, leading it by correspondences, inversions and contrasts, blocking its progress by ruptures and gaps, or deflecting its path so that something new comes to light. The pictures are scattered with symbols that imply the presence of language, or at least some structured system of signification, while specifying nothing: crosses, zig-zags, dotted lines, oriental characters (as a mountain climber, Fern particularly likes *yama*, the Japanese symbol for mountain) and fragments of letterforms turned on their side so that they read as code or notation. Sometimes, as in the triangular works, the image's shape is itself a symbol. 'It's important that I don't understand it,' Fern says of the ephemera he collects. 'As soon as I do it's a barrier to seeing it clearly.' Much the same taste for uncertainty and suggestion is at work in his pictures. From music, which he invokes as often as he does the visual arts, Fern has learned the importance of rhythm and the repeated phrase, and the power of introducing moments of discordance into a grand harmonic structure.

Such images are intended to stand in their own right, but Fern is cautious when discussing their relationship to the mainstream of gallery art. The radical illustrators he taught in the mid-1970s argued that illustration had been short-changed by the fine art world for too long, and that it was indeed possible for some kinds of commissioned

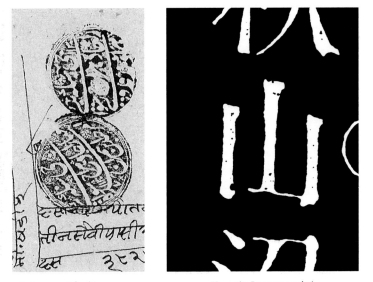

Indian postal franking stamps
(Collection Dan Fern)

Yama: the Japanese symbol
for mountain

13

work to attain a level of self-expressive intensity and conviction equal to fine art. There was a time, they pointed out, when all art was commissioned by a patron: why should this in itself be seen as a damning limitation? Illustrators were, moreover, just as capable of originating images of their own as so-called fine artists. Whatever the quality of the evidence, it is fair to say that the art establishment has not heard these complaints. Very few commercial illustrators, Warhol apart, have succeeded in breaking into the art world on equal terms with fine artists. Hardly any exhibitions are ever devoted to the subject of illustration and the professional art journals keep their distance, despite the fact that the visual landscape is flooded with illustrated imagery in obvious need of intelligent assessment. Fern's own view of the matter is typically realistic. Trained illustrators might draw on the discoveries of the major artists – Fern himself takes inspiration from Matisse, Rothko, Motherwell and the Californian painter Richard Diebenkorn, while owing an obvious debt to Kurt Schwitters – but their chances of joining those ranks are slim. It has always been far easier for artists such as Picasso, Miro or Hockney to move in the other direction.

'My concern is that these restraints shouldn't reduce our level of intent,' Fern noted in a lecture in 1988. 'Our aim should be to retain the highest possible level of artistic expression within the framework of whatever we happen to be working on. Ephemera it may be, but it is reproduced by

Richard Diebenkorn: *Untitled*
(charcoal drawing on paper, 1986)

the tens of thousands and seen by a far wider audience than most fine artists could ever hope to reach. This fact alone provides us with a terrific responsibility to produce work of quality…. In my own work I've found it invaluable to set time aside to make pictures for their own sake. I've found time after time that this has had the effect of revitalizing my commercial work. It is in effect an area of research where I can explore new ideas and media, while at the same time trying to produce pictures which can stand in their own right, and might just transcend the level of ephemera. It's important, though, that this area of work is not regarded as something fundamentally different from applied work.'

Equally important to Fern as a teacher and artist is the idea that an illustrator's art, like that of a painter or sculptor, should develop. Too many talented illustrators, he believes, lock themselves into a single, highly recognisable style, which, though at first original and much in demand, rapidly becomes passé and eventually turns into a prison. To avoid the same mistake, Fern watches his own work, with the mixture of spontaneity and detachment he has learned from teaching, for indications of the possible directions he might take in the future. His observations of the stylistic evolution of artists he admires – Mondrian's move from figuration to formalist abstraction; Rothko's rejection of surrealism for abstract expressionism – reveal how dramatic some of these changes might be. Fern recognizes in retrospect, though he could not have anticipated it at the time, that

his concerns of the 1980s were foreshadowed by a couple of small abstract collages he produced during his final year in Amsterdam in the early 1970s. For a number of years Fern has been making drawings (some of which are shown for the first time in this book) by using erasers to create lines against pencil backgrounds; more recently he has started to paint over old printed work using bold, gestural brushstrokes. None of these experiments is entirely resolved, and it is far too early to draw any firm conclusions about the paintings in particular, but the experiments are evidence that this highly sensitive artist could before long be producing work as different from the pieces collected here, as they are from his designs of two decades ago.

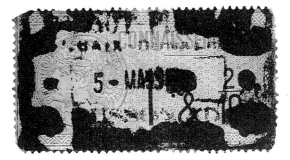

Postal sticker with extensive ink cancellation (Collection Dan Fern)

Drawing

Drawing is a very important part of my work process. I will rarely produce a drawing as a 'finished' piece, although I can foresee a time when I might. The sort of drawing I do can be divided into two areas: the first (pages 18–21) is simply a way of thinking aloud, if you like. So although I will use a very simple, linear, diagrammatic sort of drawing, I am actually thinking in terms of producing the final piece in collage and print. I am not particularly concerned that the drawing should be complete in itself – it is simply a way of helping me to make a start on a finished piece. Having said that, I use good materials when I draw and I work in a nice book; it's important that the process should be aesthetically pleasing. I work on a small scale, in a pocket book with a soft pencil.

The second sort of drawing is much more and end in itself. These drawings are much larger and although they are not intended for public consumption, I take great care over them. They are an area of visual exploration which is invaluable to my work and they usually incorporate type or letterforms, sometimes with collaged elements. The drawings are usually done in monotone – mostly black or sanguine. The drawings on pages 24 and 28–34 were done by laying a sheet of paper over a trayful of wood type and taking a rubbing using Conté, charcoal or graphite and then wiping away the rubbing with turpentine-soaked rag, leaving fragments of type showing, then maybe adding collage elements, usually a letterform, or a fragment of script or text.

Gouache and pencil on newsprint
430mm x 235mm

A6 sketchbook (Chinagraph)

Machine shop marvels

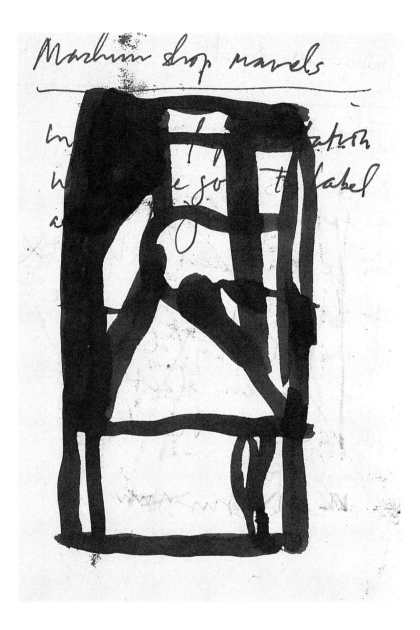

A6 sketchbook (brushpen)

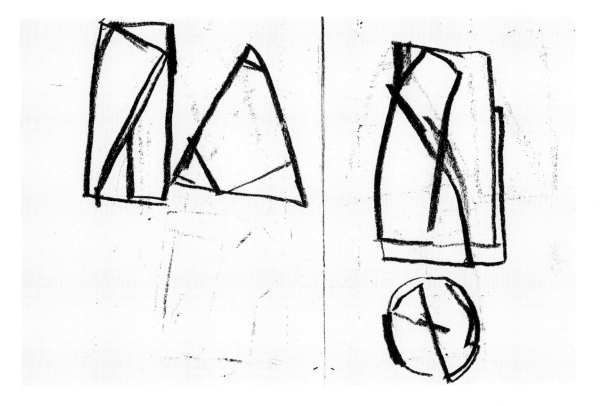

A6 sketchbook (Chinagraph)

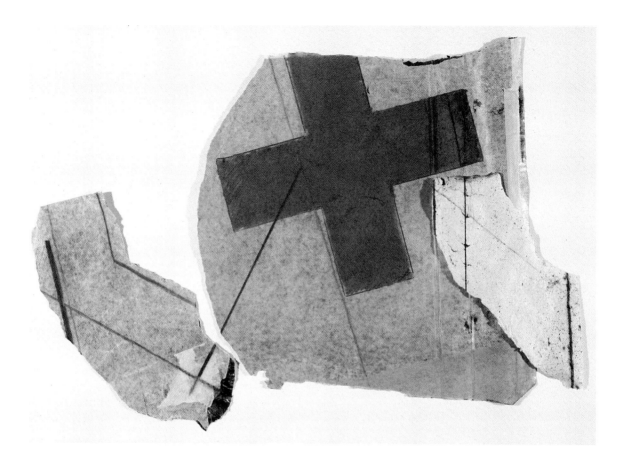

Charcoal on tarred paper
460mm x 630mm

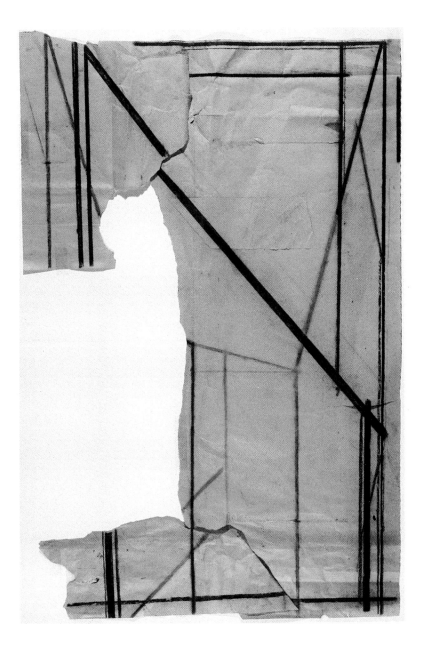

Charcoal on wrapping paper
900mm x 610mm

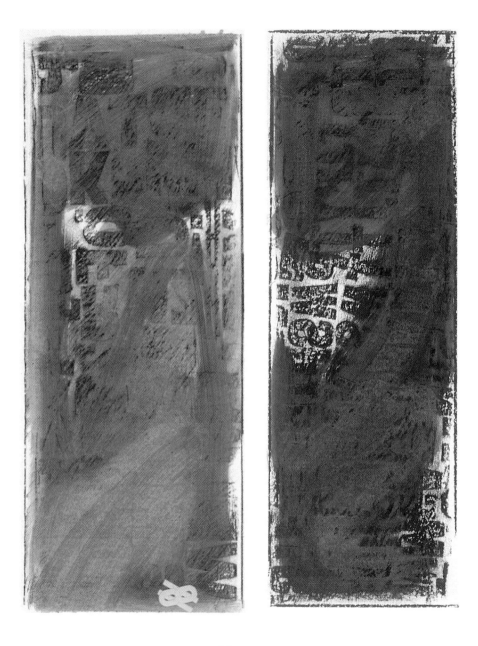

Oil crayon on paper
(Left) 680mm x 240mm
(Right) 760mm x 300mm

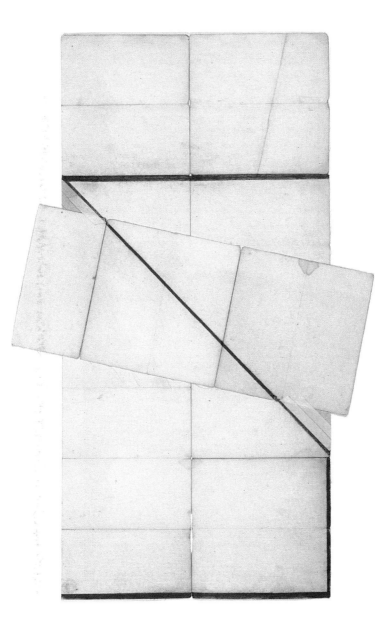

Sanguine on linen paper
800mm x 540mm

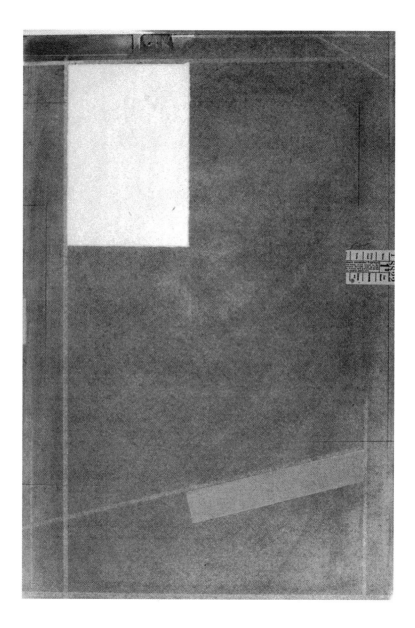

Graphite on paper with collage
550mm x 380mm

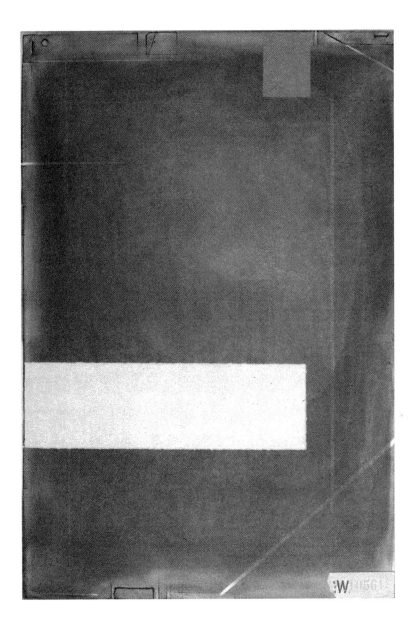

Graphite on paper with collage
550mm x 380mm

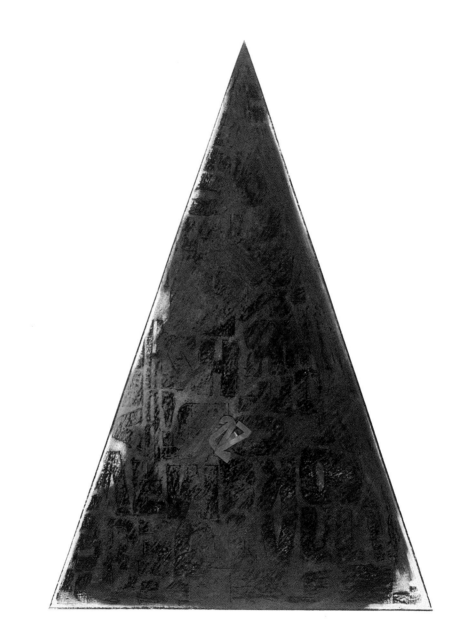

Oil crayon on paper with collage
750mm x 520mm

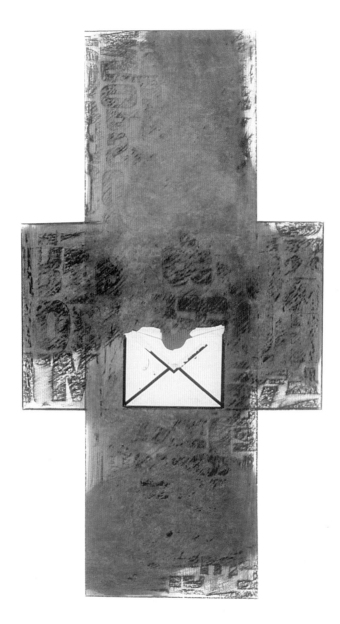

Oil crayon on paper with collage
780mm x 450mm

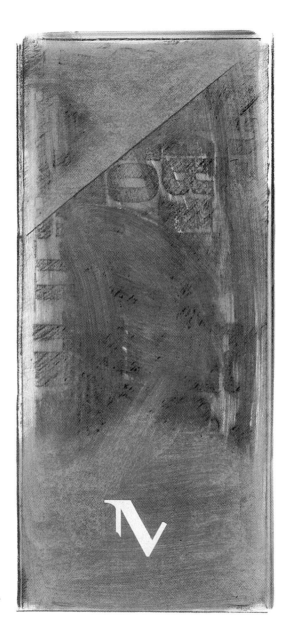

Oil crayon on paper with collage
770mm x 380mm

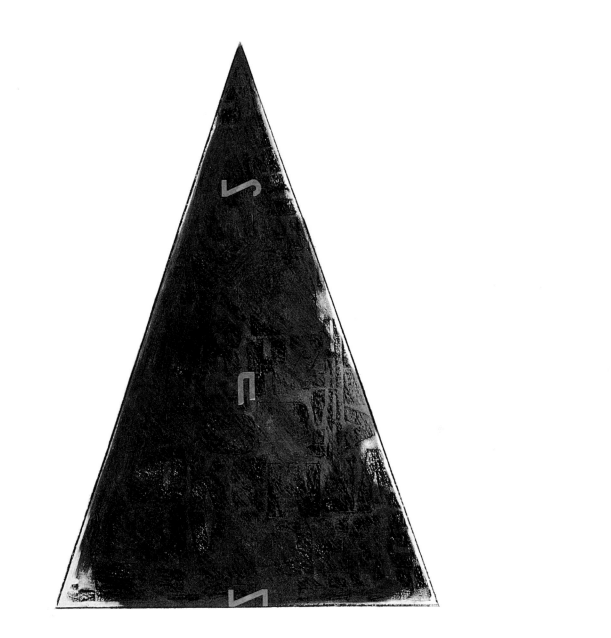

Oil crayon on paper with collage
750mm x 520mm

31

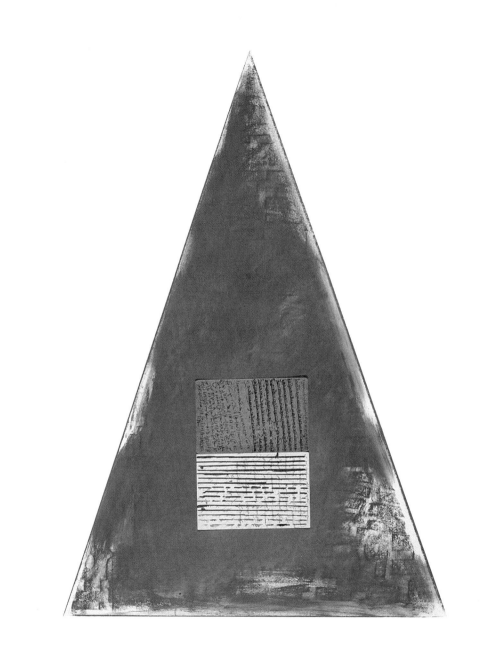

Sanguine on paper with collage
730mm x 520mm

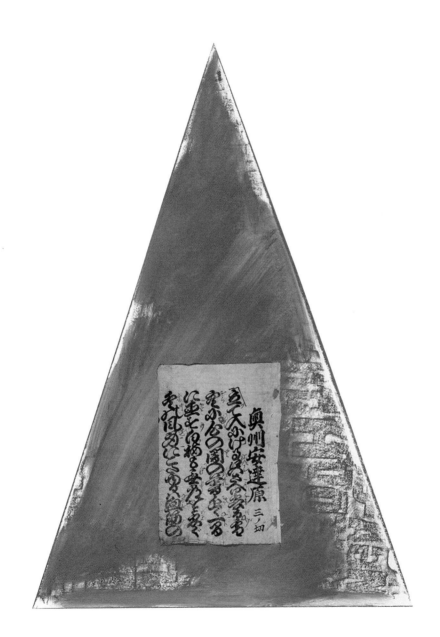

Sanguine on paper with collage
730mm x 520mm

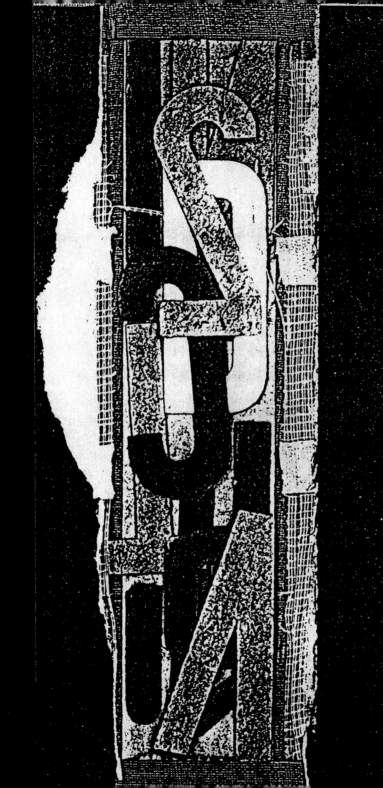

Collage

As well as working as a professional illustrator and designer there is an area of my work which is not usually commissioned, where I can develop various themes and obsessions free of any outside restraint. I suppose the biggest differences between this self-generated work and my other projects are that it is not printed, it can be any size or shape, and it doesn't have to relate to a particular text, or article, or piece of music. The pictures I make are about the things that interest me most: structure, colour, type and letterforms, the look of languages (I have travelled a lot and I am fascinated by the forms that written language can take), balance and rhythm. There are some forms and symbols that I keep coming back to – the ziggurat, the cross, the triangle. I usually work in sets; most of the pictures reproduced here belong to a series of anything up to twenty pictures, though they are not intended to be in sequence and I might produce them over several years.

I had exhibited this sort of work from time to time throughout the 1970s, but in 1982 I had my first one-man show at the Curwen Gallery, London. It was the first time I had seen a substantial body of my own work in the same space and I learned a great deal: which pictures worked and which didn't. Since then, I have exhibited regularly and this aspect of my work has become more important than ever. I always have a few self-generated pictures in progress and in between working on commissioned projects I work on those. It is all very much part of the same process.

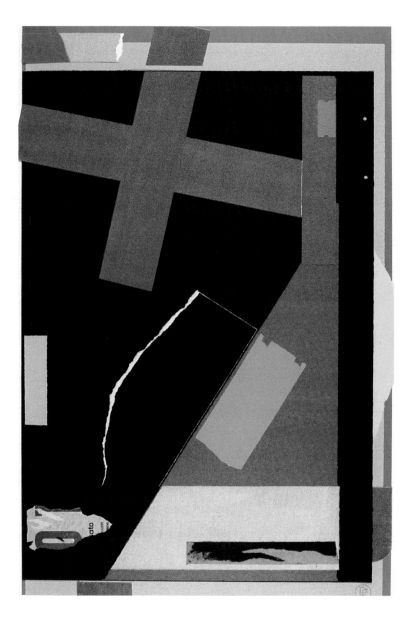

RED CROSS (1983)
Collage on board
810mm x 550mm

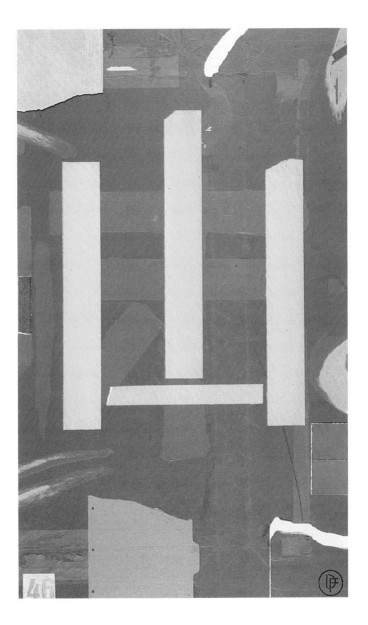

YAMA (1985)
Collage on board
1200mm x 730mm

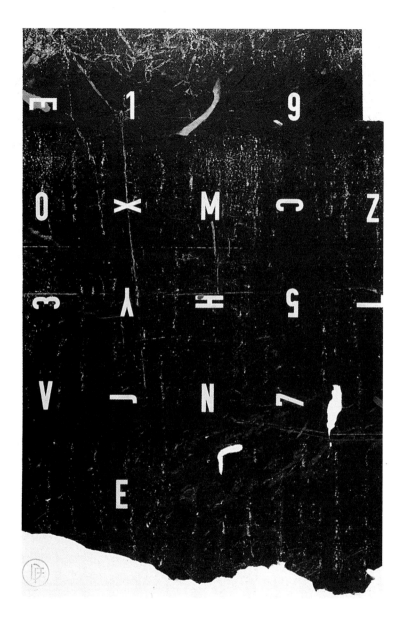

TYPE CONSTRUCTION (1984–5)
Collage on tarred paper
1200mm x 730mm

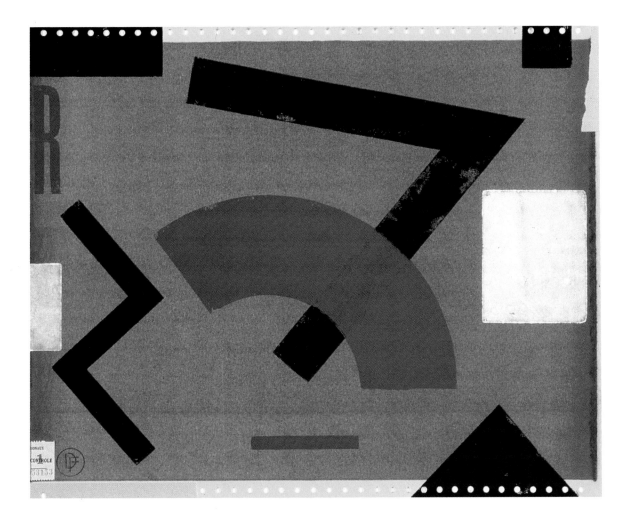

LIST (R) (1982)
Print and collage on paper
350mm x 460mm

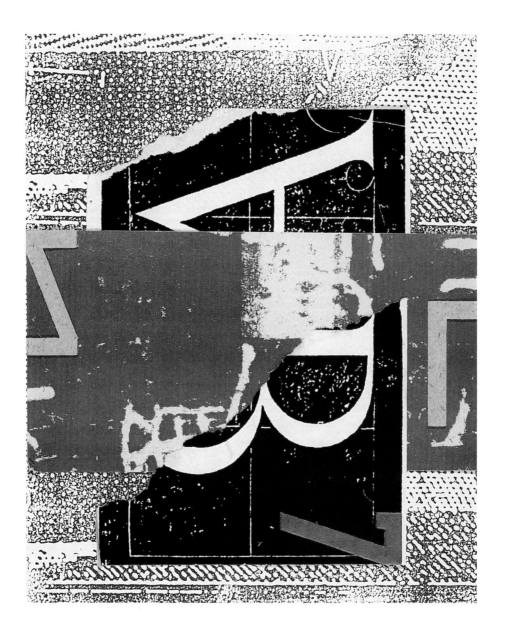

LIST (BT) (1989)
Design for a rug
Collage
180mm x 180mm

42

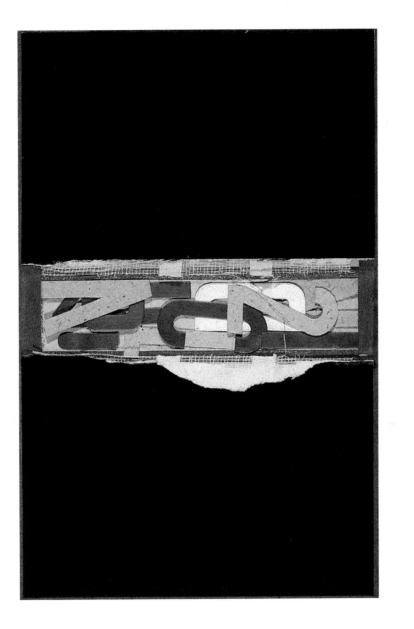

FRATRES (1) (1990)
Collage
250mm x 170mm

FRATRES (3) (1990)
Collage
300mm x 220mm

FRATRES (2) (1990)
Collage
300mm x 220mm

45

46

47

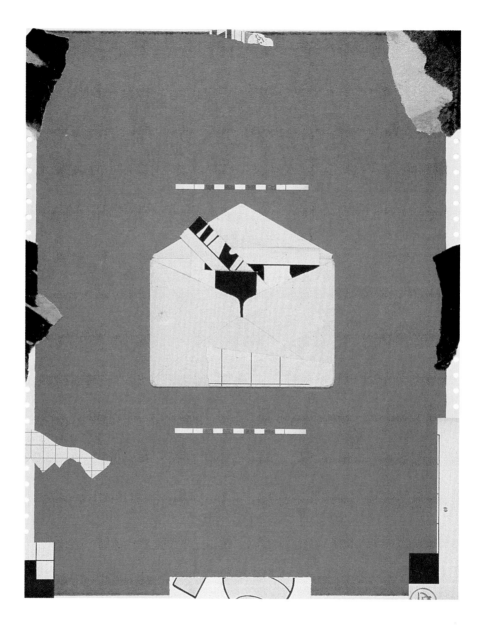

Preceding pages: Design for a rug (1990)
Collage 390mm x 210mm
Above: ENVELOPE (1981)
Collage on paper 460mm x 350mm

48

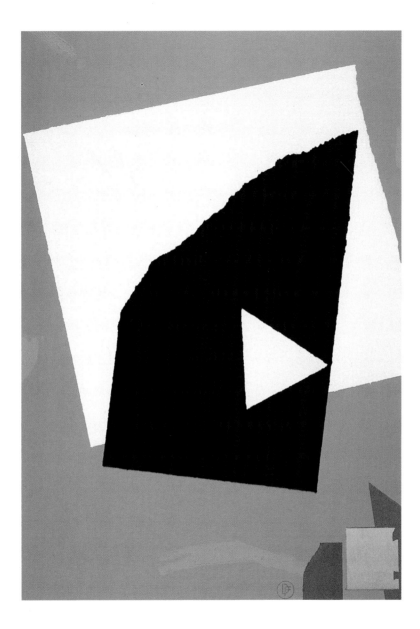

TILT (1985)
Collage on paper
940mm x 830mm

49

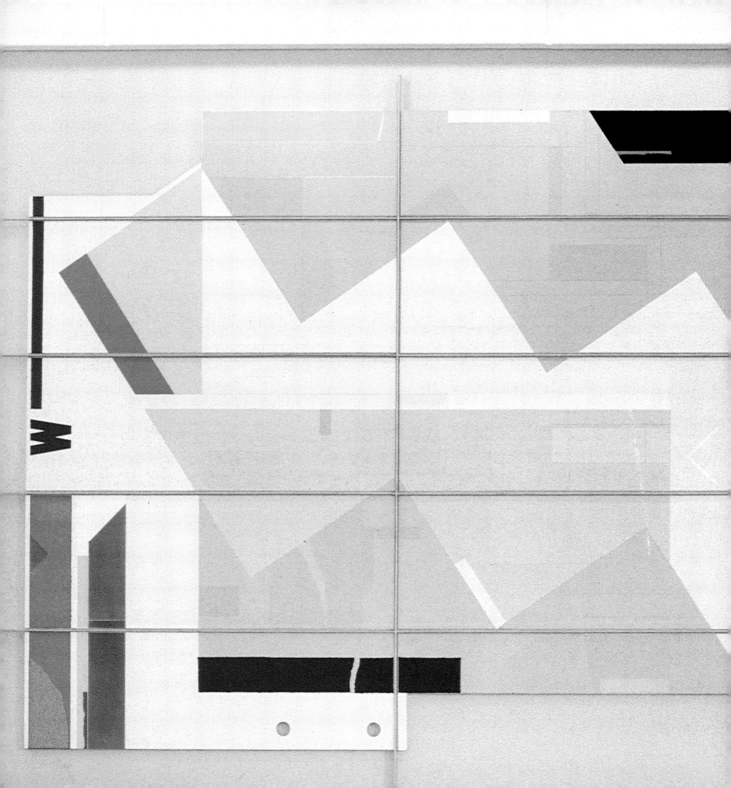

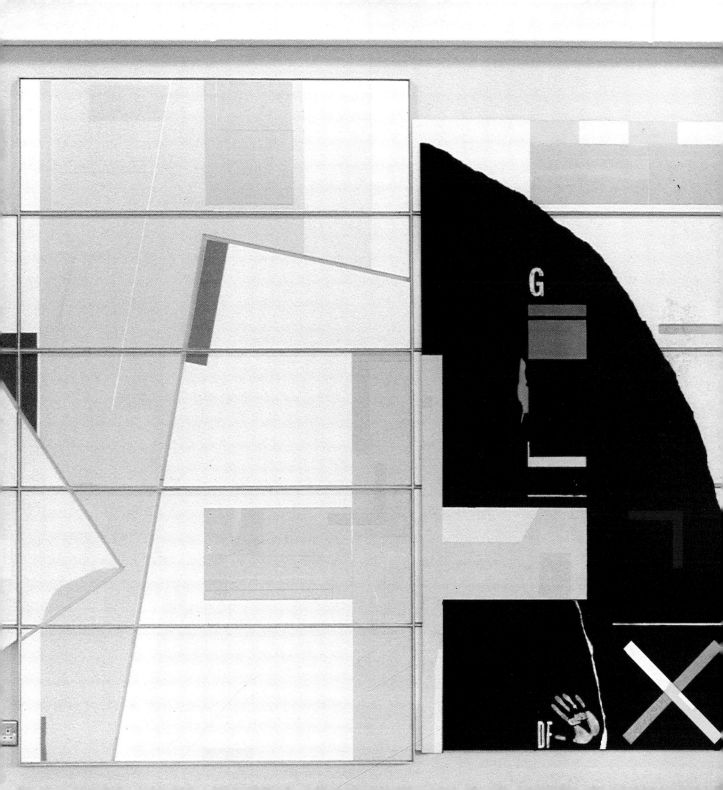

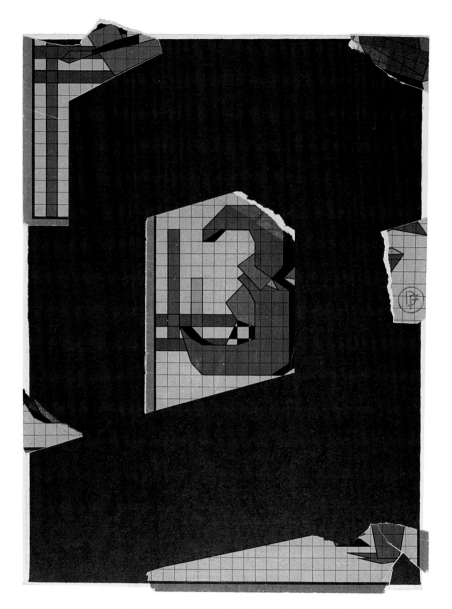

Preceding pages: W/T/G/2 Mural for Wiggins Teape (1983)
Collage on canvas-covered board
5240mm x 2250mm
This page: NO. 3 (1982)
Collage on paper 470mm x 360mm

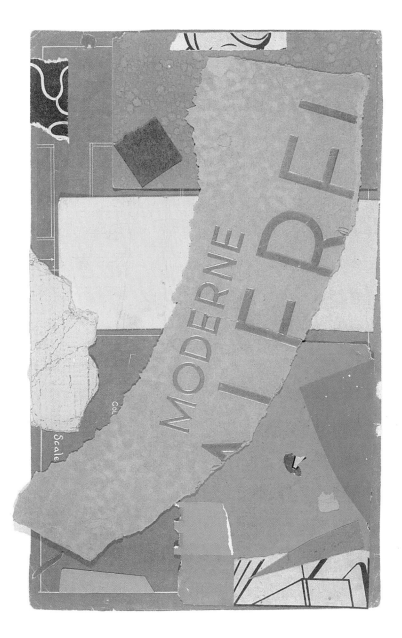

MODERNE (1987)
Collage on paper
340mm x 220mm

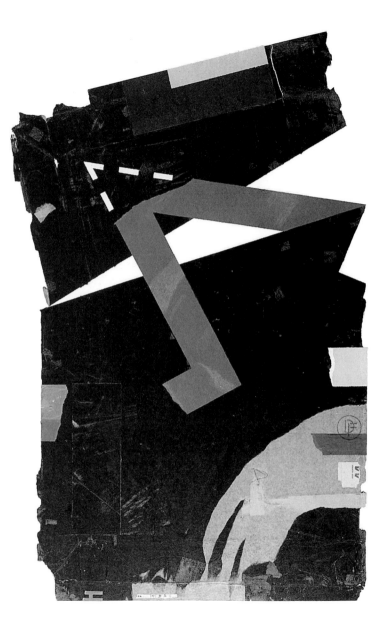

DECONSTRUCTION (1985)
Collage on board
1200mm x 770mm

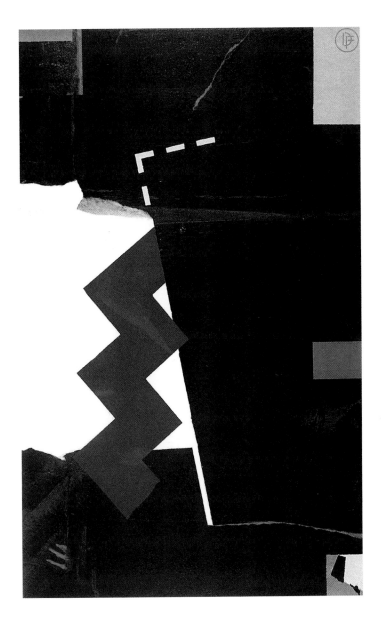

FROM BEHIND (1985)
Collage on board
1340mm x 830mm

55

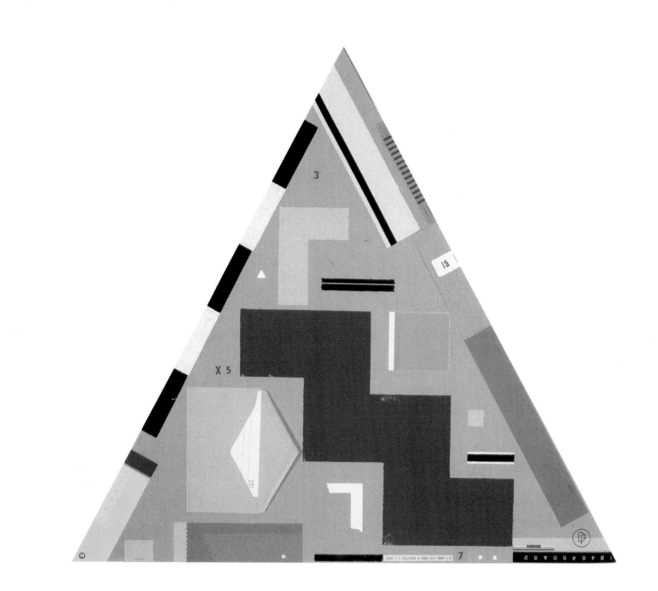

STEP LIST (X5) (1981)
Print and collage on wrapping paper
650mm x 680mm

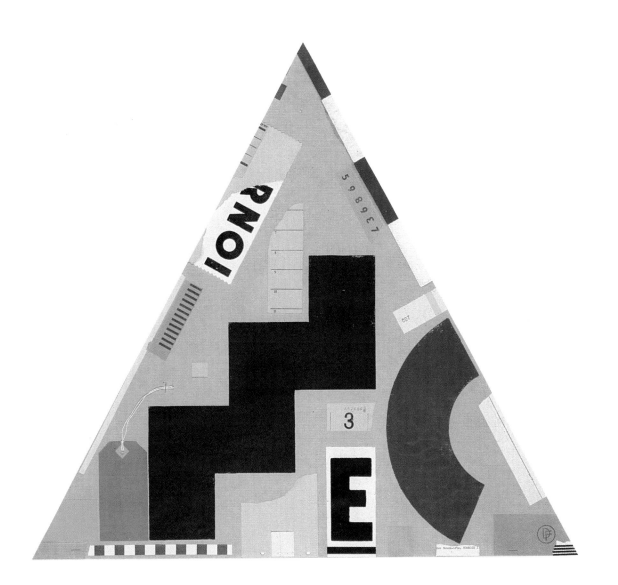

STEP LIST (E3) (1981)
Print and collage on wrapping paper
650mm x 680mm

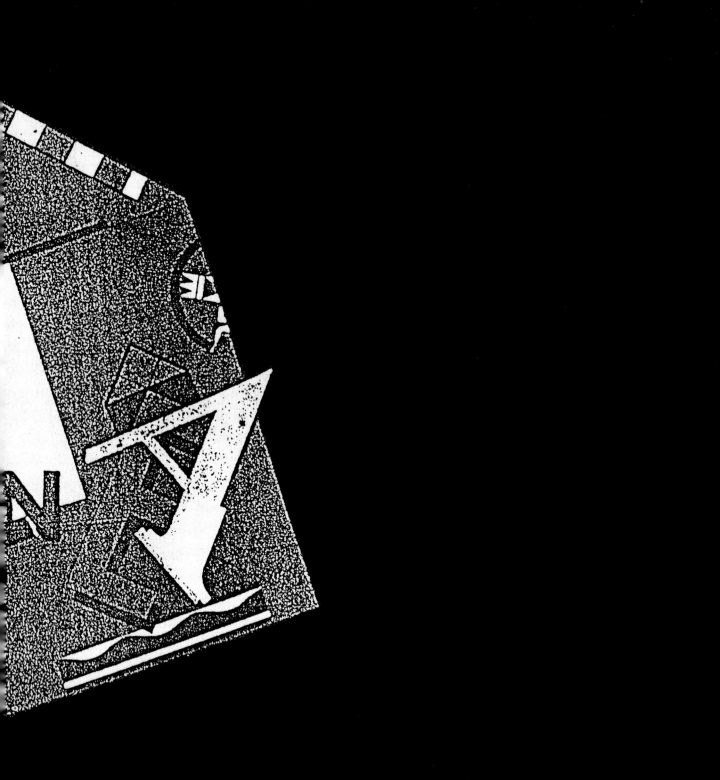

Print

It wasn't until five or six years after leaving the Royal College of Art that I reached a point where I was consistently producing commercial work with which I could feel completely satisfied, work which felt true, grew directly out of my own interests and involved the minimum of compromise.

After I have been briefed about a commission by the client or the art director I do nothing with it for a couple of days. I will think about it from time to time and when I have decided more or less how I am going to do it I start collecting together things which are relevant. This might include collage elements or photographic material, sometimes just coloured scraps or typographic fragments. I start manipulating the various elements within a roughly sketched format until the collage starts to look 'right', by which I mean that it has reached the critical point of balance between my own aesthetic interests and the specific requirements of the brief. At this point, I tack it lightly together with tape and pin it on the wall. For the next few days (if there is time) I glance at it occasionally while I am doing other things. I rarely change the collage radically at this stage, though if I become aware that it is not going to work out I will take it apart suddenly and completely. I show it to the client and art director in this tacked-together form, so that they can see exactly what it will look like (I don't do 'roughs') and if it is all right I can fix it within a few hours.

60

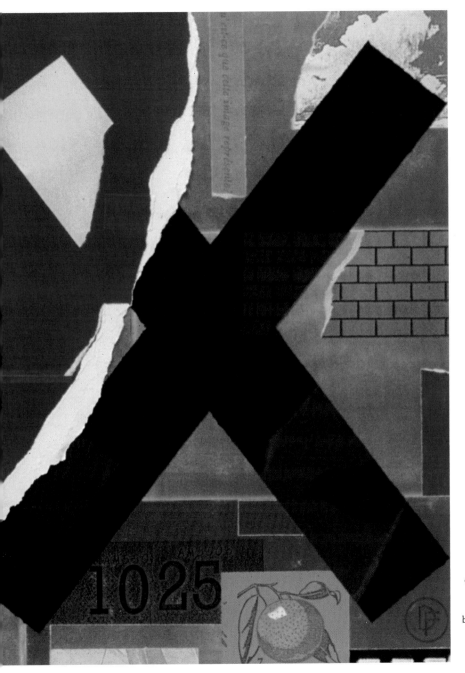

RX1025
Double-page advertisement made
using one of the 1985 generation of
colour copiers. The theme being
colour, the picture contains a number
of references to colour – orange, sky
blue, brick red, lemon yellow, jet
black, etc. In the centre is the Japanese
symbol *aoi* which means blue.
Client: Rank Xerox
Agency: Young and Rubicam

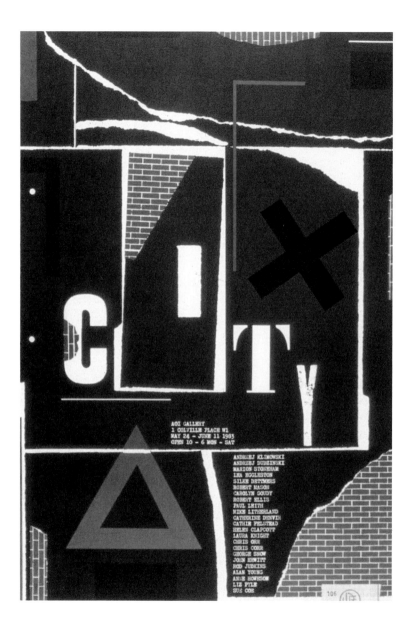

CITY (1983)
A poster for an exhibition by various artists on the theme of the City.
Client: Association of Illustrators

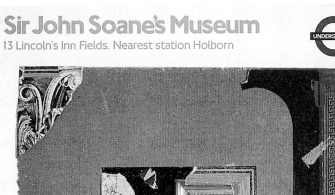

Sir John Soane's Museum
13 Lincoln's Inn Fields. Nearest station Holborn

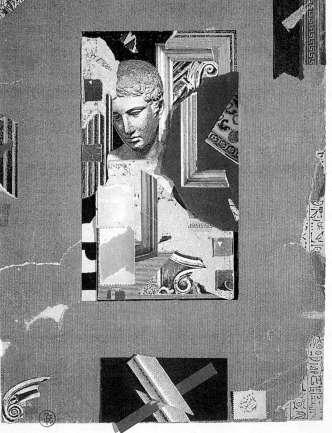

Sir John Soane's Museum (1987)
John Soane was an architect who built an extensive collection of
objects from around the world which he housed in a beautifully
designed museum in Lincoln's Inn Fields, London.
Client: London Regional Transport

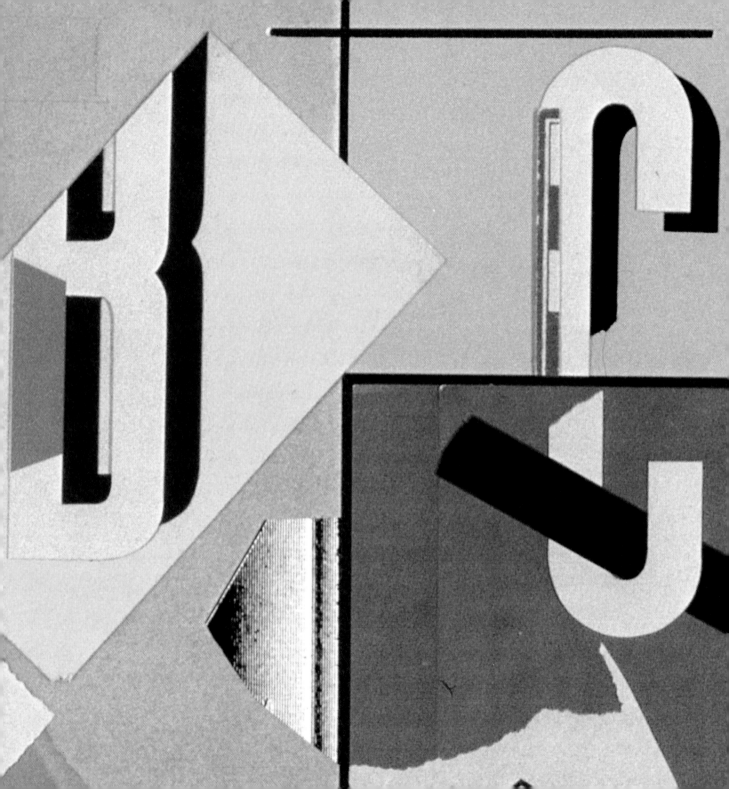

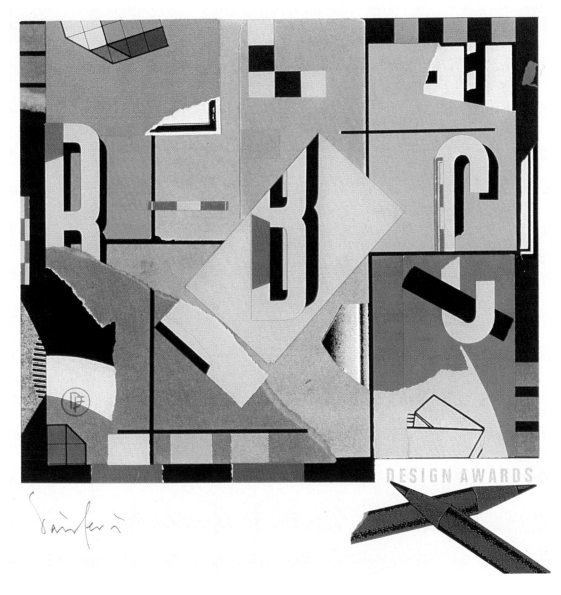

BBC Design Awards (1987)
A print commissioned by the BBC which was given to the winners
of awards in various categories (architecture, industrial design and
graphics). The print was in offset with added elements –
collage, rubber stamp, handwriting.

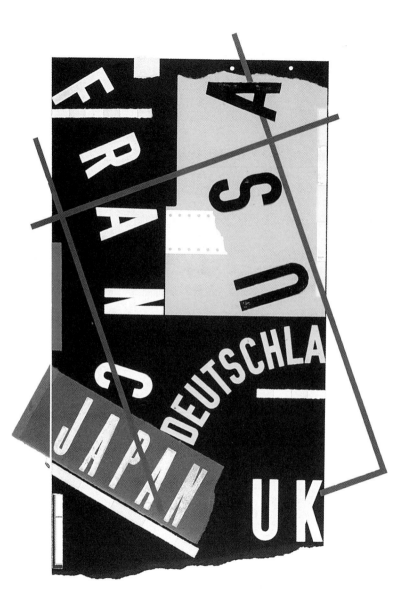

CROSS-BORDER DATA FLOW (1984)
Illustration for *IRM* (*Information Resource Management*), a magazine
dealing with aspects of communications technology.
Client: Ericsson
Design group: Pentagram

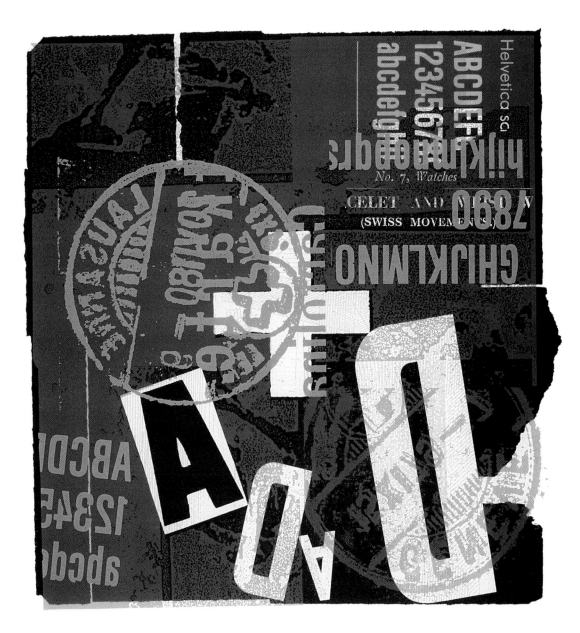

A-AUGST (1989)
Calendar illustration referring to a small town in Switzerland.
Client: Trickett and Webb

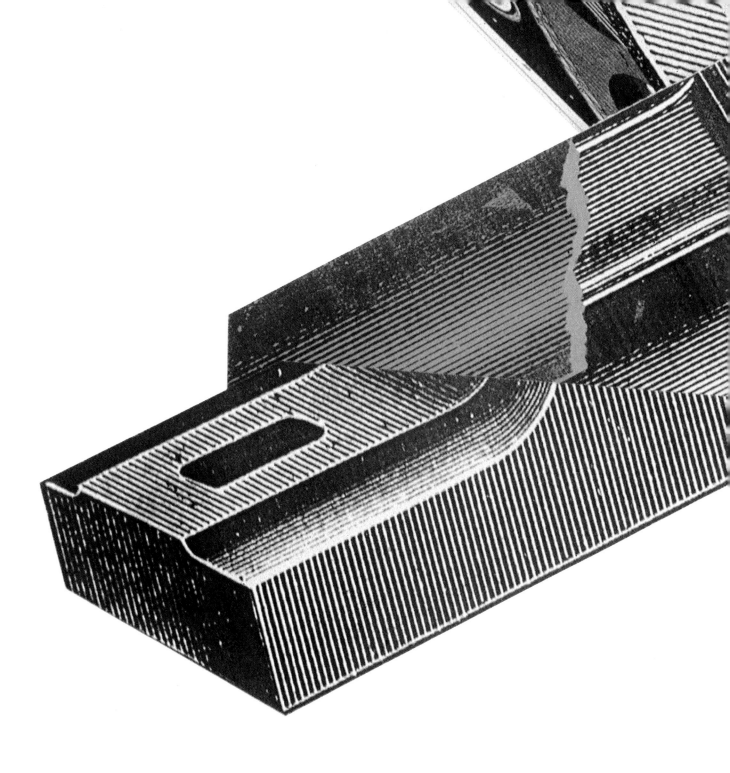

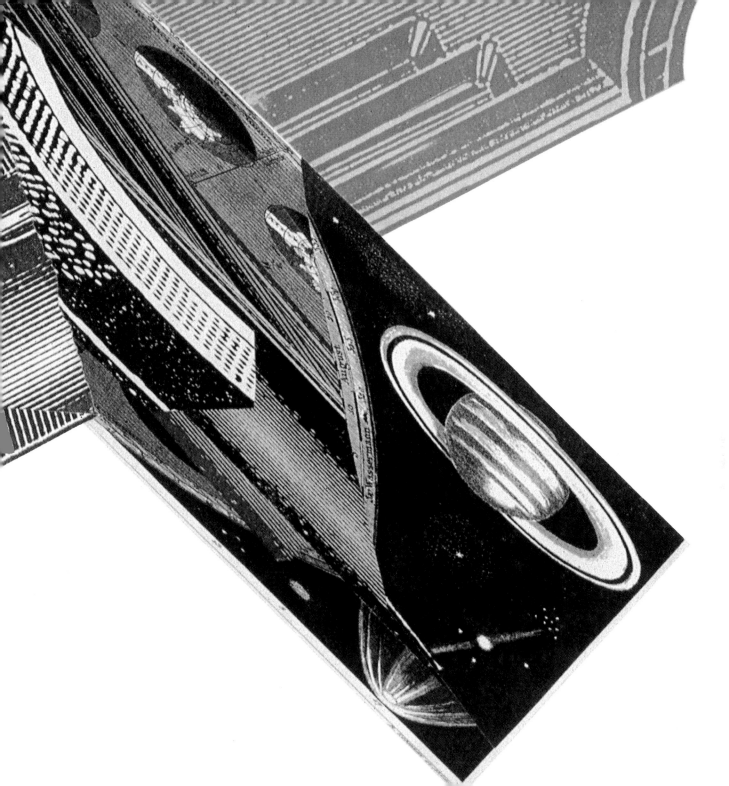

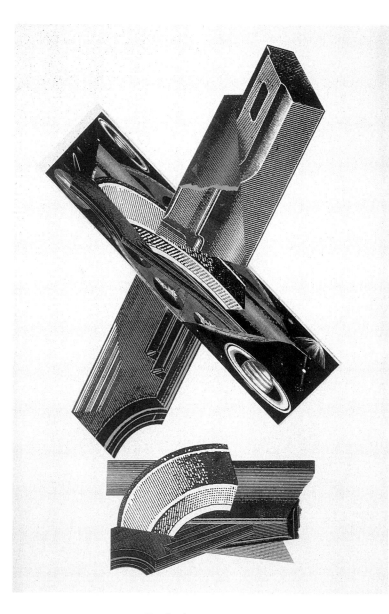

'Doorbraak' poster (1989)
Commissioned by Bührmann-Tetterode to mark their sponsorship of 'Doorbraak'
(Breakthrough), an exhibition of work by illustrators from the Royal College of Art
which transferred to the Berlage gallery in Amsterdam
Preceding pages: detail the same size as the poster

U.S.A. (by air) $2.00 ISSN 5028-6664 **22 April 1982** Vol 94 No 1302 Weekly 70p

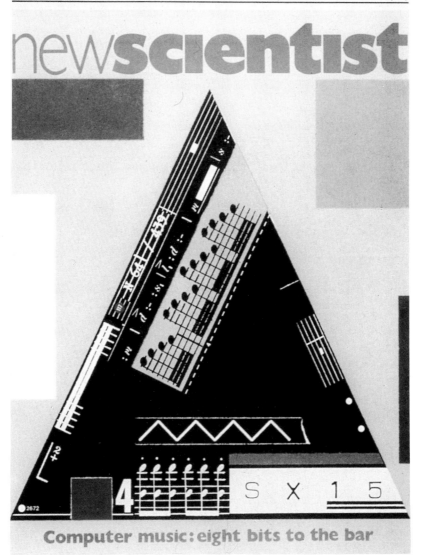

Computer music: eight bits to the bar

COMPUTER MUSIC (1982)
A cover for *New Scientist* magazine.
Client: IPC Magazines
Art Director: Chris Jones

71

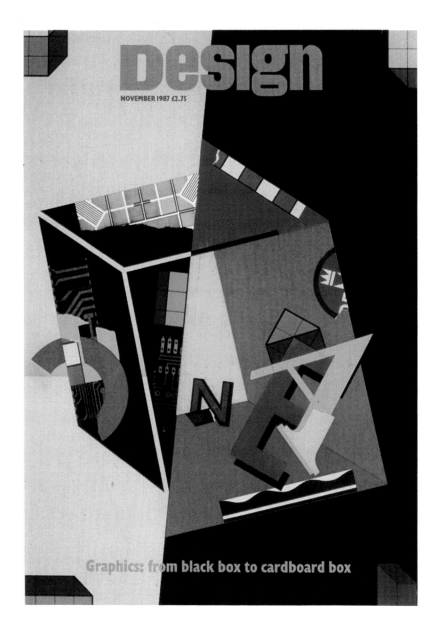

Design (1987)
A cover for an issue of the magazine featuring contemporary
packaging design
Client: The Design Council

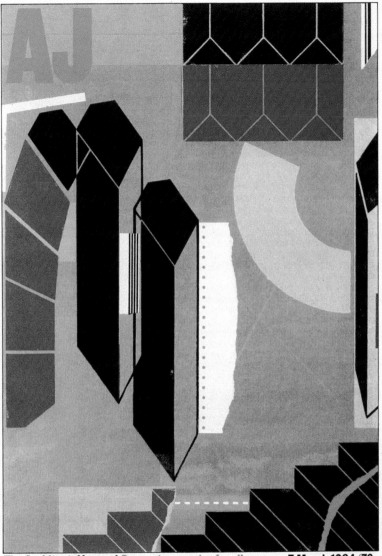

The Architects' Journal Derngate: a centre for all seasons 7 March 1984/70p

Architects' Journal (1984)
The cover story was about an innovative theatre design and the
picture was based on architectural drawings and plans.
Client: Architectural Press

73

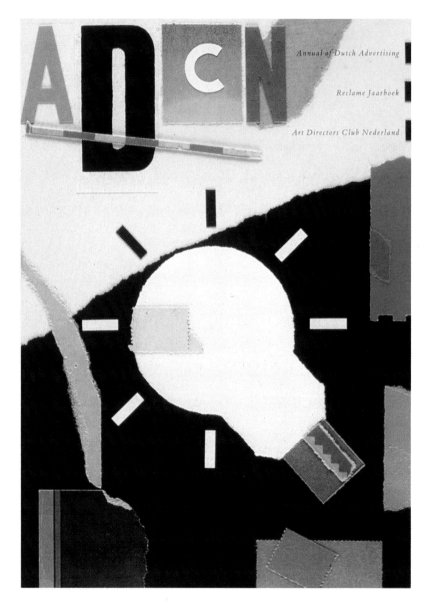

Annual of Dutch Advertising (1986)
Pages 74–83: Illustrations for the cover, endpapers and double-
page section headings of the Art Directors Club Nederland annual.
The light bulb is the symbol of the ADCN.
This page: Cover

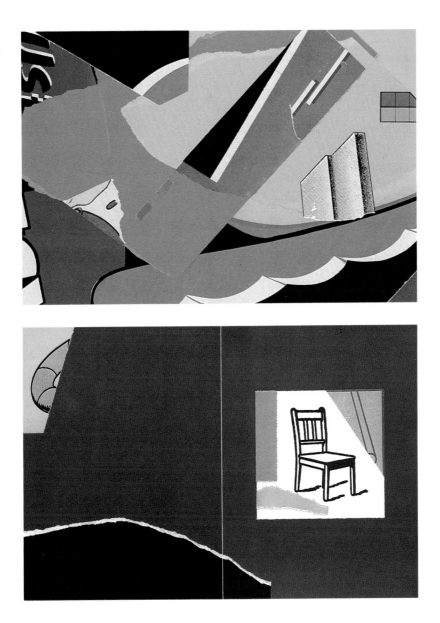

Top: Endpapers
Bottom: Section heading, Chairman's Report

75

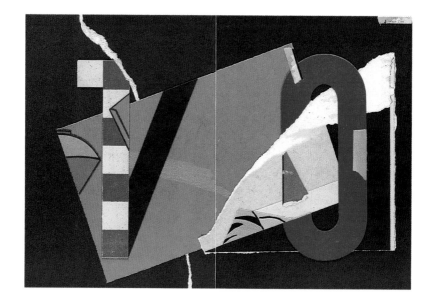

Section heading, Selection of the Jury of Ten

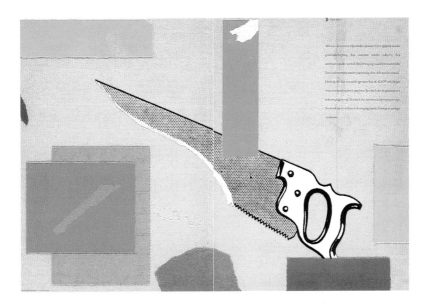

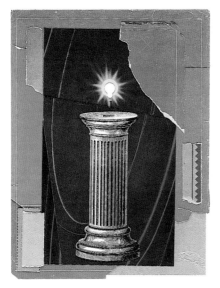

Top: Section heading, Chairman's Report
Bottom: Section heading, Main Awards

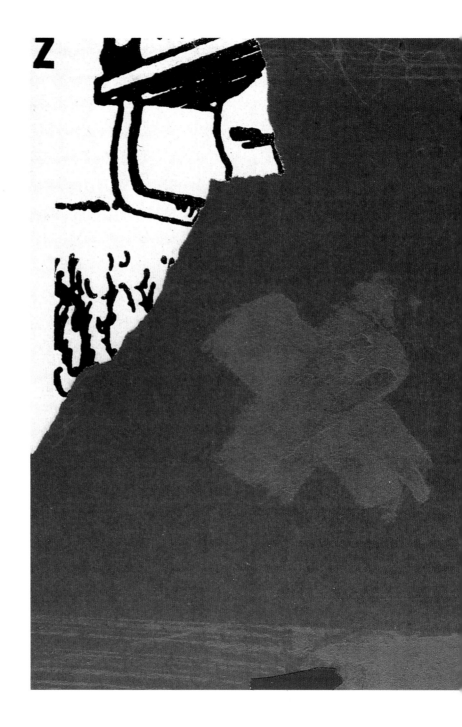

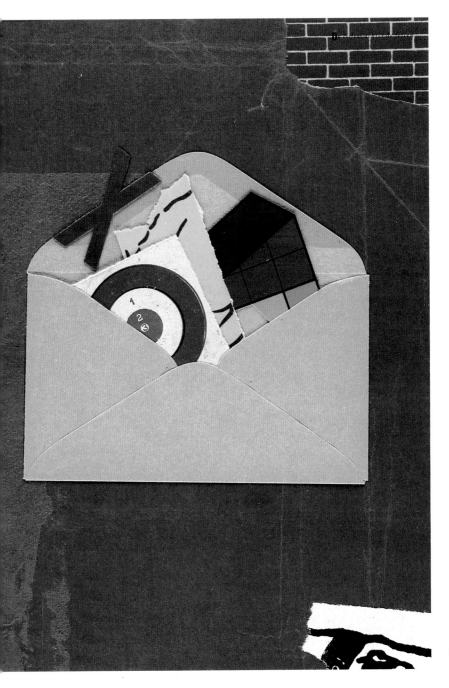

Section heading, List of Submissions for
the Annual

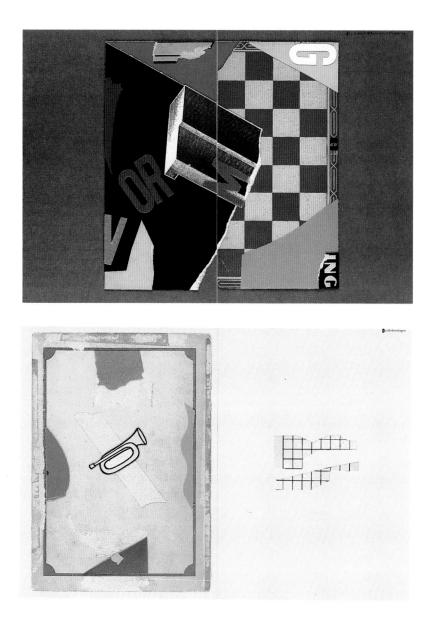

Top: Section heading, Design Category Awards
Bottom: Section heading, Sponsored Awards (1)

80

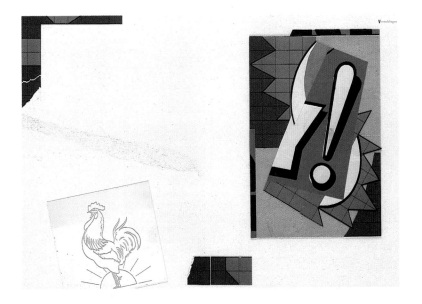

Section heading, Sponsored Awards (2)

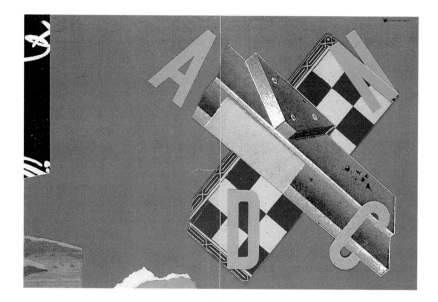

Section heading, Membership List of the ADCN

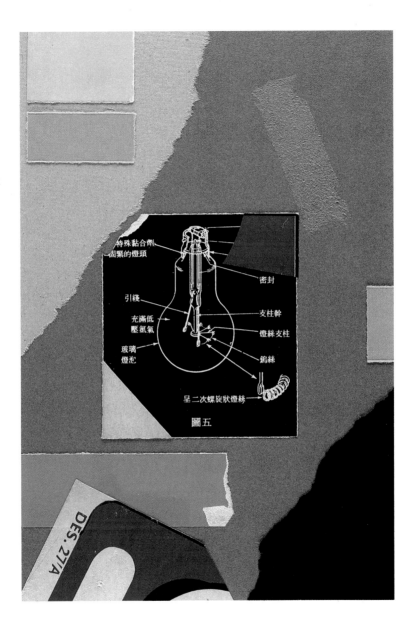

圖五

特殊黏合劑
鹵緊的燈頭

密封

引綫

支柱幹

充滿低
壓氫氣

燈絲支柱

玻璃
燈泡

鎢絲

呈二次螺旋狀燈絲

DES.27/A

Back cover

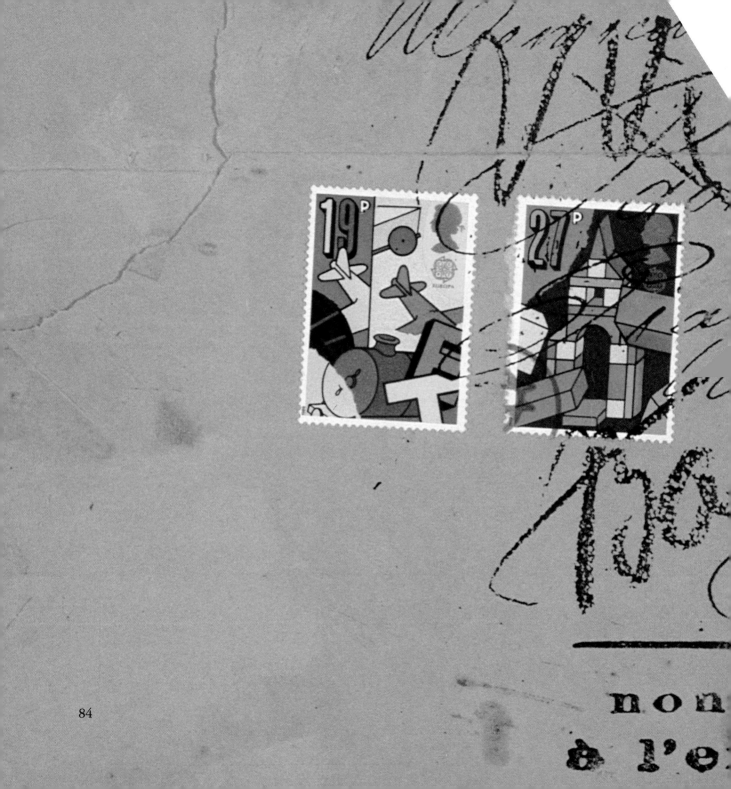

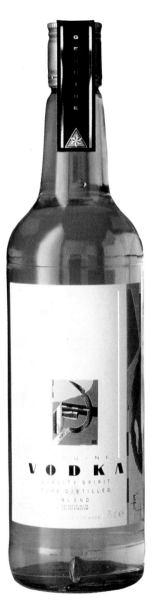

Above: Vodka label (1988)
Client: Asda
Typography and art direction: Lewis Moberly
Opposite: TOYS AND GAMES (1989)
Two from a set of four stamps commissioned by the Royal Mail.

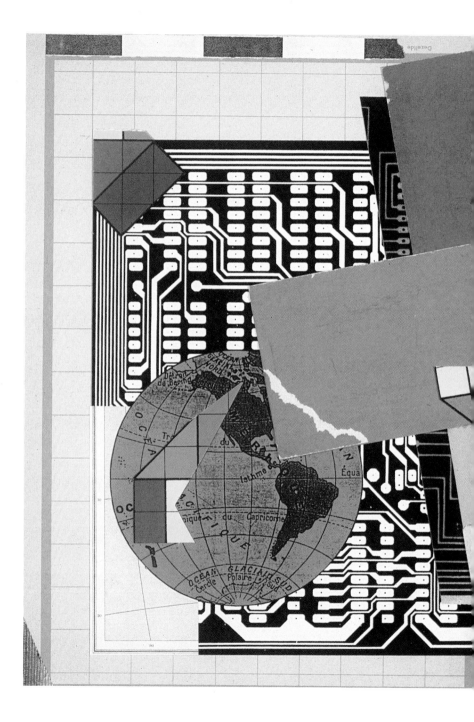

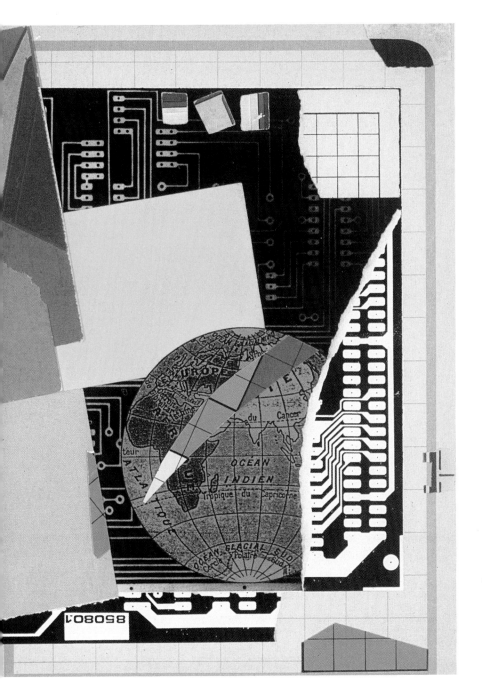

KMPG annual report (1987)
Spread from an annual report,
showing the company's international
communications network. The
company is divided into four
sections, each represented by a
separate colour throughout the
report.
Client: KMPG
Agency: VVTH (Amsterdam)

87

Logo design for Mario's Restaurant (1983)

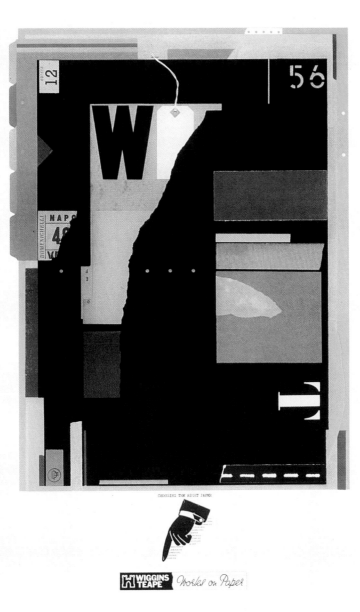

WT poster (1982)
One of a series by several designers to show various aspects
of the manufacture and use of paper.
Client: Wiggins Teape
Design group: Trickett and Webb

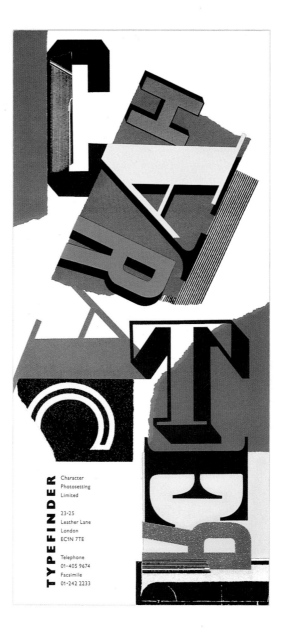

Character (1989)
Design for the cover of a type catalogue. The design was
subsequently adopted as the company logo.

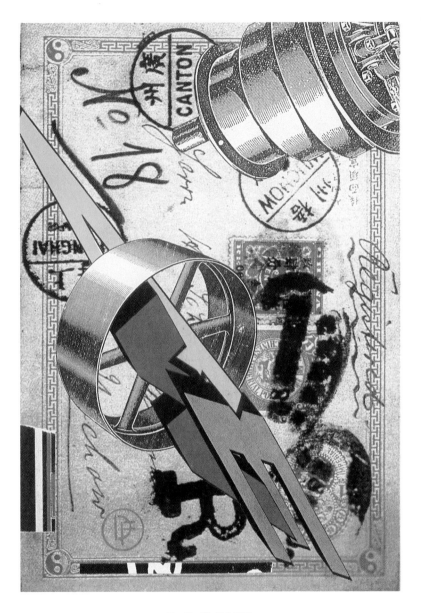

Graphics World (1989)
An image from a series of illustrations for an article about colour
photocopying. The pictures were produced by combining several
functions of one of the Color Laser Copiers donated by Canon UK to
the Royal College of Art as part of a four-year research programme.

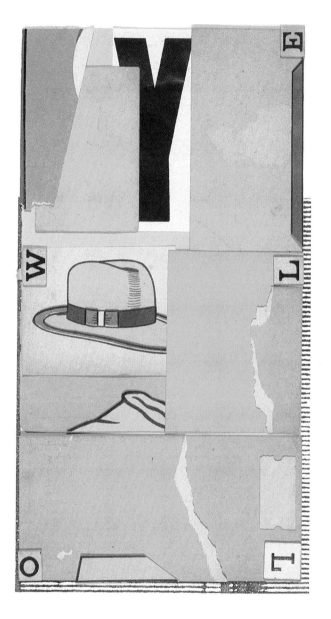

YELLOW (1990)
From a series of posters on the theme of colour.
In progress

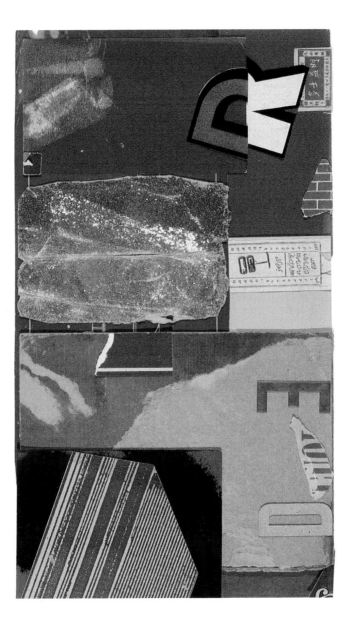

RED (1990)
From a series of posters on the theme of colour.
In progress

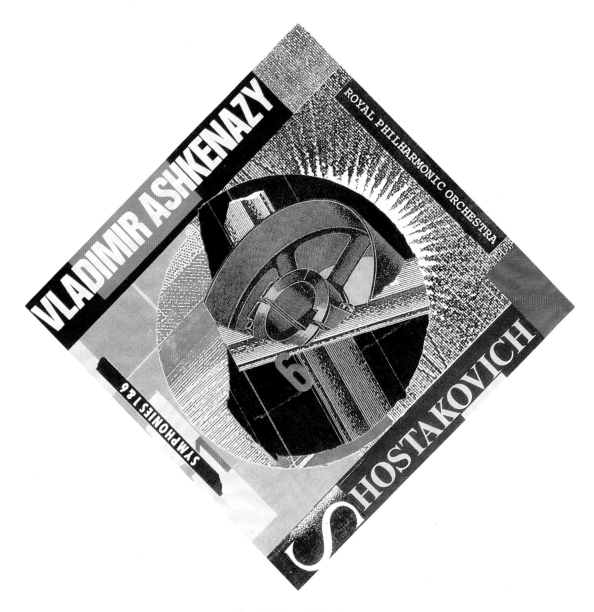

VLADIMIR ASHKENAZY

ROYAL PHILHARMONIC ORCHESTRA

SYMPHONIES 1 & 6

SHOSTAKOVICH

Shostakovich symphonies (1990)
Above and opposite: Two from a series of covers for
compact disc and tape cassettes.
Client: Decca
Art Director: Ann Bradbeer

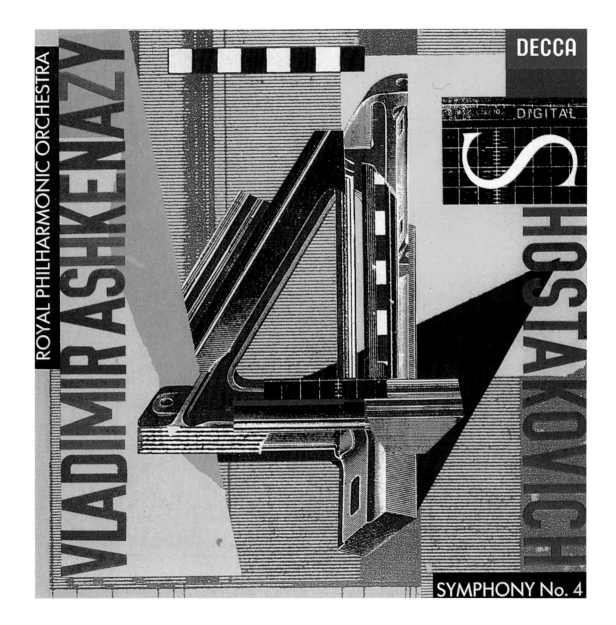

ROYAL PHILHARMONIC ORCHESTRA

VLADIMIR ASHKENAZY

SHOSTAKOVICH

DECCA

DIGITAL

SYMPHONY No. 4

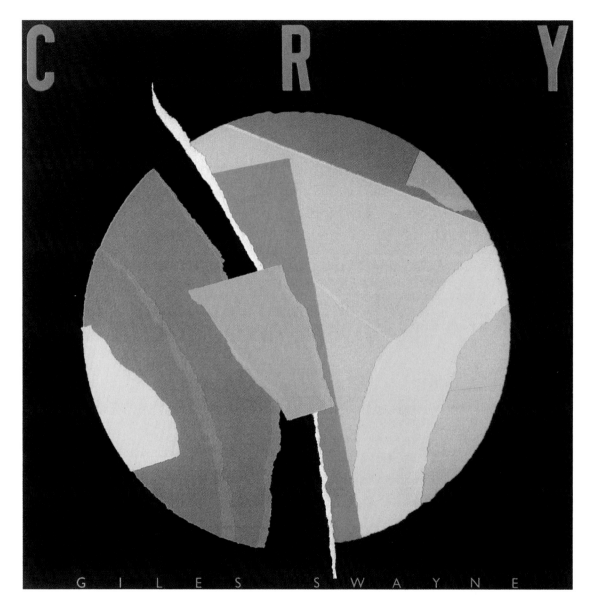

CRY (1985)
Record sleeve for a contemporary choral work by
Giles Swayne on the theme of The Creation.
Client: BBC Records
Art Director: Mario Moscardini

THE FLIGHT OF AMY JOHNSON IN 1930
Illustration for the 1984 Trickett and Webb calendar. Each of the
twelve artists was asked to picture a memorable event in any year
except 1984

Teaching

When I took over from Quentin Blake as head of illustration at the Royal College of Art in 1986, my commitment to education naturally took a quantum leap. I became far more involved in the administration not just of the department, but of the college as a whole.

For the last fifteen years I have lectured in colleges all over the UK and I enjoy it immensely. I love art schools. I feel completely at home in them; they seem to me to be an ideal working environment. The more I see of art education overseas, the more firmly I think that a good British art school is an excellent place to be educated, not just in the narrow sense of learning professional skills – although, of course, that is important – but in a much broader, richer sense.

We have a marvellous system of art education, in spite of its faults, and it should be properly maintained. Unfortunately, the politicians and others charged with the governance of art schools often simply do not understand what goes on in them – that they are fragile, highly sensitive networks of personal relationships, communities and sub-groupings built up over a long period of time and often extending beyond the college itself. If this social environment is well constructed, and if it is supported and encouraged, the creative process will flourish naturally within and around it. But even then it is not easy. The education of an artist or designer consists of a whole series of highly speculative explorations which sometimes work and often don't. The process is further complicat-

ed because the criteria by which art and design is evaluated are in a constant state of flux. We assess something today on the basis of what we may only have found out yesterday. Artists are opportunists, gamblers, explorers, exploiters, hunters. The making of art is not a process that lends itself easily to 'rational' scrutiny and as a consequence the arts in general, and art schools in particular, are all too vulnerable at the hands of those who can only appreciate the measurable, the tangible, the profitable and the cost-effective.

Teaching at somewhere like the RCA is a particularly subtle and demanding process. The people we get at the college are all postgraduates and they are highly committed and often very innovative artists; that is why we choose them. So there is no question of teaching at this level being simply about passing on information. It is really about making connections: between people, between people and media, materials, places, and ideas. One of the interesting things about illustration is that it has become an area where all sorts of disciplines meet and overlap – 'fine' and 'applied' art, traditional and recently developed media. This makes the range of possibilities open to us enormous and makes it more critical than ever that we develop heightened senses of selectivity and judgement. And at the heart of it all is the individual student and the particular set of circumstances and experiences which led them to where they are, producing their own special kind of work; our aim, within the short time they spend with us, is to try to help them match their hopes and ambitions with some viable way of working as professional artists.

My work as a teacher involves lecturing, assessing, examining, running workshops, doing tutorials and reviews, setting up and overseeing research projects, mounting exhibitions, trying to find sponsorship, and so on. Added to the administrative load, it is demanding and I sometimes find the right balance between academic and professional careers very hard to maintain. Increasingly, the sort of pictures that I want to produce require intense concentration, even meditation. That takes silence, and time, and isolation. The great danger for those deeply involved in teaching is that they spend so much time and energy encouraging and promoting other people that they simply lose sight of their own work, and from time to time that is certainly a problem for me. But I could not over-emphasize the debt I owe to my association with the RCA. As well as being able to select and then work alongside some of the most interesting and talented contemporary artists and illustrators, both staff and students, I have had to develop ways of analysing, evaluating, criticizing and articulating every aspect of picture-making, and, of course, that has been for the most part beneficial to my own work. That is the critical thing: to learn that everything you do, everything, contains elements which are usable in some way, and that you can build up a store of possibilities, ideas, projects and plans, so that there is always something you really want to move on to.

VOL DE NUIT (1978)
Cover for a limited edition publication, Royal College of Art

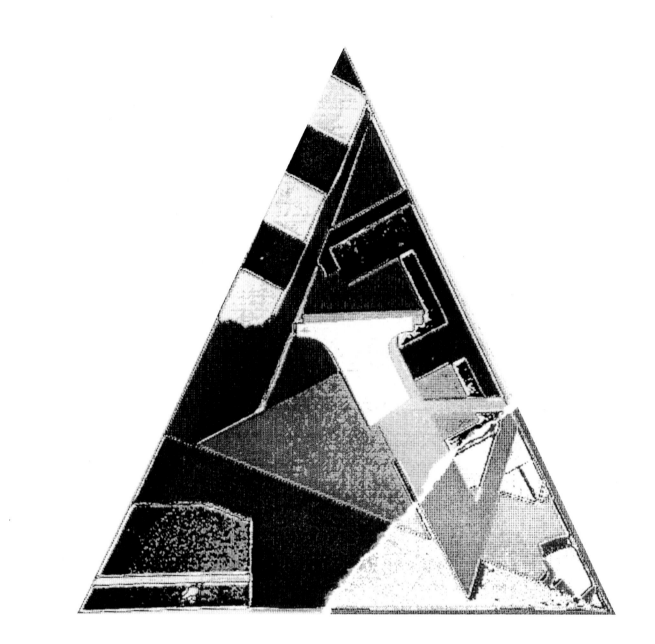

CONSTRUCTION (1989)
A limited run print made for the *Breakthrough* catalogue (computer-
generated and reproduced on a Canon Color Laser Copier)

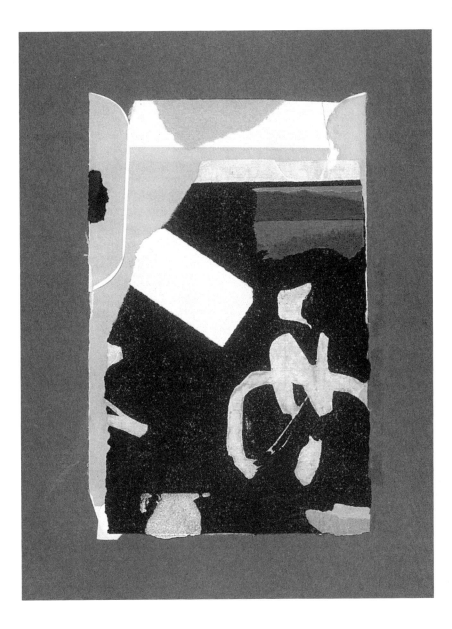

CHINESE DISH (1980)
Recipe illustration for Royal College of Art cookbook

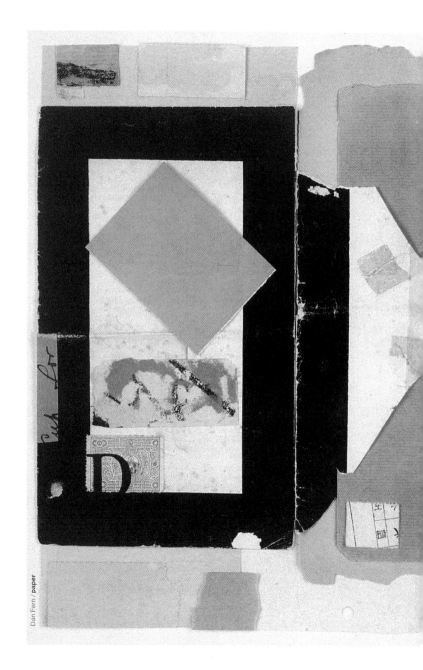

Dan Fern / **paper**

104

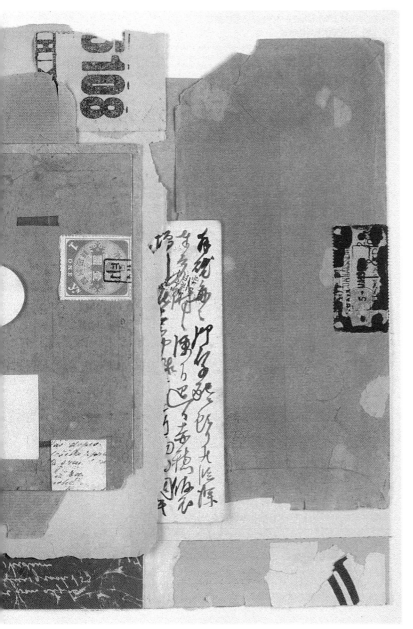

PAPER (1989)
Double-page illustration for an annual report.
Client: Bürhmann-Tetterode

Biography

DAN FERN

1945	Born Eastbourne, Sussex
1956–64	Queen Elizabeth School, Gainsborough, Lincolnshire
1964–67	Diploma, Graphic Design, Manchester College of Art
1967–70	MA, Illustration, Royal College of Art, London
1970–73	Lived and worked in Amsterdam
1986	Head of Illustration, RCA

ONE-MAN EXHIBITIONS

1982	'Print and Collage Constructions', Curwen Gallery, London
1985	'Collage, Print and Type Constructions', Curwen Gallery, London
1986	'Dan Fern: Recent Work', Entrepotdok, Amsterdam

GROUP EXHIBITIONS

1979	'Art/work', National Theatre, London
	'Images to Order', Arts Council
	Warsaw Poster Biennale
1983	'Collage', Curwen Gallery, London
1984	'Homage to Hergé', Joan Miro Foundation, Barcelona
1984	Bath Festival Centenary Exhibition, Bath
1984–85	'10 Years of European Illustration', Cooper-Hewitt Museum, New York, and the Smithsonian Institution, Washington
1986	'Art Meets Science', Smiths Gallery, London
	'British Illustration from Caxton to Chloë', British Council
	'Art at Work', Aspen Design Conference, Aspen, Colorado
	Curwen summer exhibition, Curwen Gallery, London
1988	'Breakthrough', Royal College of Art, London (curator)
1989	'Doorbraak', Berlage Museum, Amsterdam (curator)
	'RCA in Japan', Axis Gallery, Tokyo
1990	'Image and Object', National Museum of Modern Art, Kyoto

CLIENTS: FREELANCE ILLUSTRATION AND GRAPHICS 1970–90

Advertising Agencies: Doyle Dane Bernbach, J. Walter Thompson, Foot Cone Belding, Franzen Hey Veltmann, Young and Rubicam

Design Groups: Conran Design, David Pocknell Associates, Michael Peters Group, The Partners, Pentagram,

Quadrant, Small Back Room, Studio Dumbar, Trickett and Webb, Wolff Olins, Yellowhammer

Magazines: *Building, Campaign, Design, Designer, DesignWeek, Graphics World, Illustrators, IRM, New Scientist, Radio Times, Saturday Night, The Sunday Times Magazine*

Publishers: The Art Book Co., Faber and Faber, Pan Books, Penguin Books, Time-Life

Record Labels: A&M, Arista, BBC Records, Chrysalis, Decca, Virgin

Various: Art Data Institute (Amsterdam), Art Directors Club Nederland, BBC Design Awards, Foco Novo, Joint Stock Theatre Group, London Regional Transport, The Singer Foundation, Royal Academy of Art, Royal Court Theatre, Royal Mail, Thames Television, Tricycle Theatre

LECTURES

Part-time lecturer at the Royal College of Art since 1974. Visiting lecturer, tutor or external examiner 1974–90: Bath, Bradford, Brighton, Chelsea, Central, Camberwell, Canterbury, Exeter, Farnham, Glasgow, Hull, Kingston, Liverpool, Leeds, London College of Printing, Maidstone, Manchester, Newcastle, Newport, Norwich, Preston, Richmond, St. Martin's, Wolverhampton. Also: The Hague Academy; Parson's School of Art, New York; School of Visual Arts, New York; Hogeschool voor de Kunsten Utrecht

GUEST SPEAKER

1980	Design and Art Direction
1985	American Illustration Workshops, New York

1986	International design conference in Aspen
1987	Mackintosh Theatre, Glasgow School of Art
1988	W. H. Smith illustration seminar, Canterbury City Hall, Hong Kong
1990	Mackintosh Theatre, Glasgow School of Art Contemporary Art Fair, Earl's Court, London

SELECTED AWARDS

1972	Gold award for illustration in press campaign, Art Directors Club Nederland. Client: Jaffa. Design: Ron Kambourian
1975	Silver award for most outstanding special series, D&AD. 'Facts of Life'. Client: *The Sunday Times Magazine*
1981	Gold award, National Gift Pack Awards. Liquid Geometry pack. Client: Loncraine Broxton
1981	Silver award for most outstanding point-of-sale, D&AD. Client: Slumberdown. Design: Pentagram
1981	Gold award for sales promotion, D&AD. Client: Slumberdown. Design: Pentagram
1986	Best book design award for non-fiction, Stichting Collectieve Propaganda van het Nederlandse Boek. Client: Art Directors Club Nederland. ADCN Annual. Design: Henny van Varik
1989	Silver award for most outstanding packaging range, D&AD. Vodka label. Client: Asda. Design: Lewis Moberly
1989	Gold award for design, D&AD. Vodka label. Client: Asda. Design: Lewis Moberly

SELECTED ARTICLES AND CATALOGUES

N. Aldrich-Ruenzel, 'Contemporary British Illustration at RCA', *Step-by-Step Graphics*, May/June 1989

Vic Allen, 'Paper Currency', *Creative Review*, February 1987

Dan Fern, 'A World of Puns, Pigs and Passion', a review of contemporary posters, *Campaign*, 1 February 1985

Dan Fern, 'British Illustration: A Renaissance', in *Art Meets Science: The Cover Art of New Scientist, New Scientist* exhibition catalogue, 1986

Dan Fern, 'The Art of Illustration', *Illustrators*, May/June 1988

Dan Fern, 'Design for Print', a review of a Design Council exhibition, *Graphics World*, June 1988

Dan Fern, *Breakthrough* catalogue, Royal College of Art, London 1988

Jonathan Glancey, 'An Illustration of Excellence in the Field', *The Independent*, 12 November 1988

Harry Obdeijn, 'Jammer dat al die advertenties er in moesten', a review of the Art Directors Club Nederland annual, *Adformatie*, 11 December 1986

Rick Poynor, 'Open to Interpretation', *Blueprint*, No. 51, October 1988

Vernon Ram, 'Dan Fern: An Illustrious Artist', *Hong Kong Standard*, 27 July 1987

Toon van Severen, 'Dan Fern illustreerde ADCN Jaarboek: "Samenleving heeft Kunstenaars hard nodig"', *Adformatie*, 27 November 1986

Graham Vickers, 'The Life and Times of Dan Fern', *Blueprint*, No. 20, September 1985

Helen Wong, 'Today Scrap – Tomorrow Art', *South China Morning Post*, 27 July 1987